DORCHESTER AND AROUND

THROUGH TIME

Steve Wallis

AMBERLEY PUBLISHING

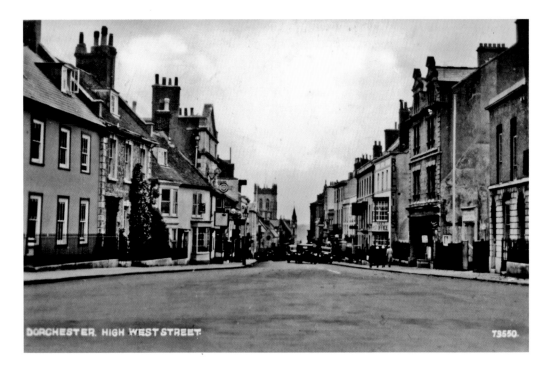

High West Street, Dorchester, *c.* 1930.

Every effort has been made to contact copyright holders. In the unlikely event that you have been overlooked, please get in touch so the appropriate credit can be included in future editions.

First published 2009

Amberley Publishing Plc
Cirencester Road, Chalford,
Stroud, Gloucestershire, GL6 8PE

www.amberley-books.com

Copyright © Steve Wallis, 2009

The right of Steve Wallis to be identified as the Author of this work has been asserted in accordance with the Copyrights, Designs and Patents Act 1988.

ISBN 978 1 84868 774 5

British Library Cataloguing in Publication Data. A catalogue record for this book is available from the British Library.

Typeset in 9.5pt on 12pt Celeste.
Typesetting by Amberley Publishing.
Printed in the UK.

Introduction

The photographs in this book are paired to allow the reader to compare old views, mostly from the first half of the twentieth century, with present-day ones. When making such comparisons, your first reaction is probably to see how things have changed. Yet in many cases very little is actually different, and in my opinion this is a distinctive feature of Dorchester.

Certainly, the suburbs have expanded considerably over the past hundred years or so, but generally developments in the centre have been sympathetic and relatively small-scale. Dorchester did not have 'its heart ripped out', as did so many English towns, particularly during development in the 1960s and 1970s. The same is true in many of the villages, with expansion on the edges but only limited changes in the historic core.

It has thus been relatively simple to work out where the earlier photographs were taken. I have tried to take my new photographs from the same locations as the old, although sometimes a wish to respect someone's privacy or avoid becoming a victim of the traffic has prevented me from doing so. I also found that some spots in the old photographs are now too overgrown to be reached — our ancestors of a hundred years ago must have been great believers in keeping vegetation under control! Even when the photographs are taken from exactly the same spot, the views may appear slightly different because of variations in older and modern cameras and their lenses.

Most of the old photographs are taken from postcards, which our ancestors of a hundred years ago used not just for holiday greetings but for more mundane communications as well. In fact, they seem to have sent them almost as often as people today send emails and text messages.

I have given dates for the older images. I most confess that most are guesses, based on such factors as the postmarks on some of the postcards and style of dress of people in the images and if the majority are accurate to within five years I will be very happy.

In writing and taking photographs for this book, it has been my pleasure to notice new things I had not seen in fifteen years' residence in the area. The opinions expressed are entirely my own, but I suspect that I am not alone in considering that the survival of so many historic features in and around the town, together with the local landscape and the sympathetic modern developments, make Dorchester a fine place to live or visit.

Steve Wallis

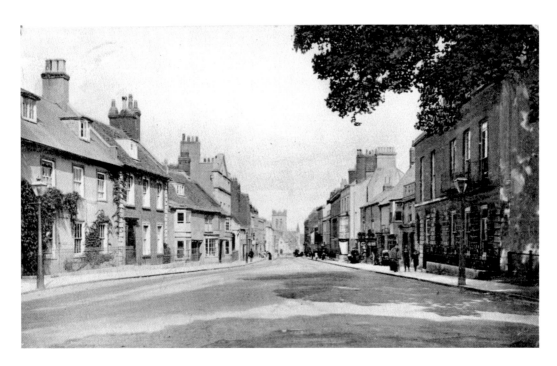

Top O' Town, *c.* 1900

We will start our tour of the town centre at Top O' Town. Historically this was the place where the main road from the west and north-west came into the town, and it remains a major road junction. It gained a roundabout about half a century ago.

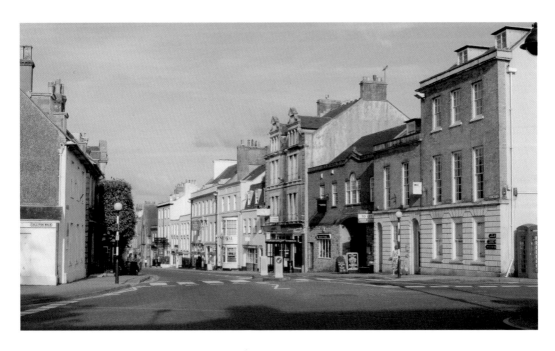

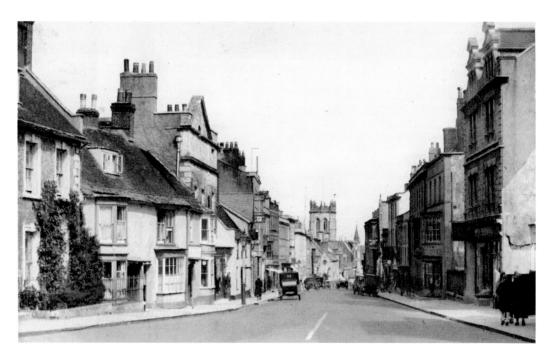

High West Street, c. 1930

These two photographs give a closer view of some of the buildings seen in the previous pair. The building on the left that is today called the Old Tea House dates from 1635 and the Rajpoot restaurant occupies a building that is only a little younger.

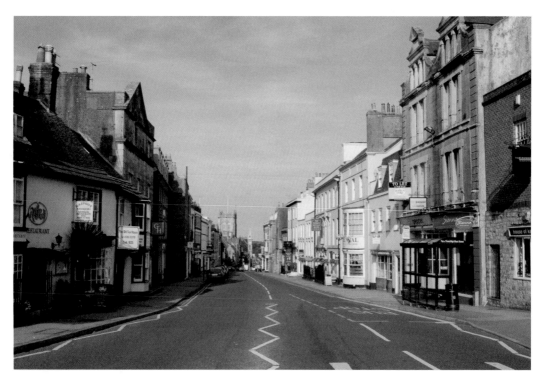

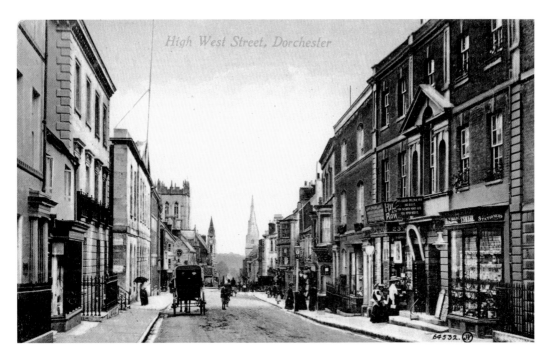

High West Street, *c.* 1900

We now move a somewhat greater distance down High West Street, but still look in the same direction. The long building on the left side (seen more clearly in the modern view) is Shire Hall, which was built in the 1790s. The Tolpuddle Martyrs were tried here, and the courtroom can still be seen inside the building, which is now part of West Dorset District Council's offices.

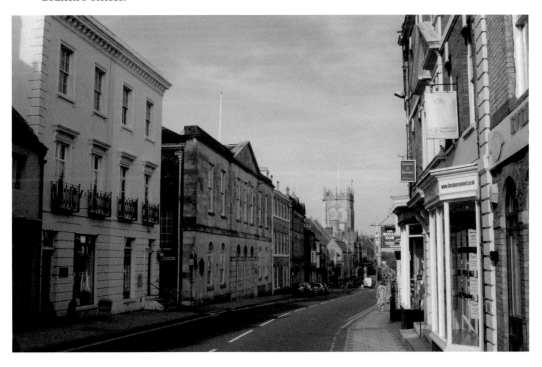

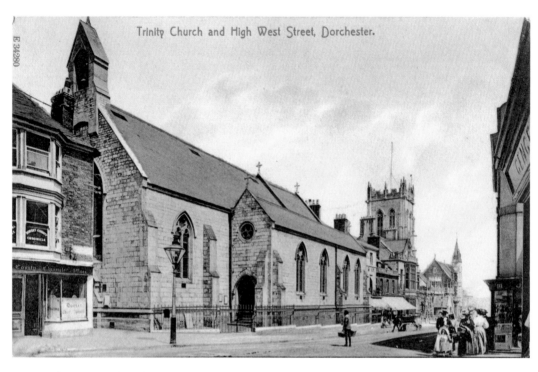

Trinity Church and High West Street, Dorchester.

Holy Trinity Church, *c.* 1900

Further down again is Holy Trinity Church. With St Peter's and All Saints' it was one of Dorchester's three parish churches in the Middle Ages, but the present building was constructed in 1875/6 to the design of the architect Benjamin Ferrey. In 1976 it was transferred from the Church of England to the Roman Catholic Church.

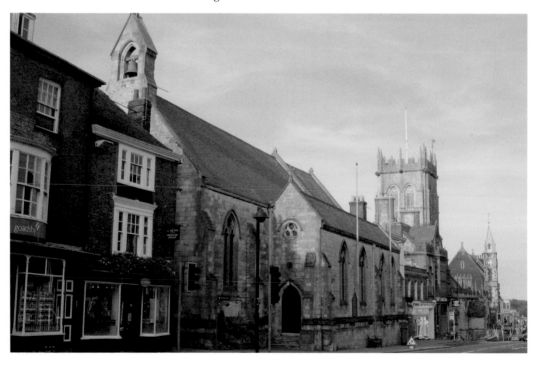

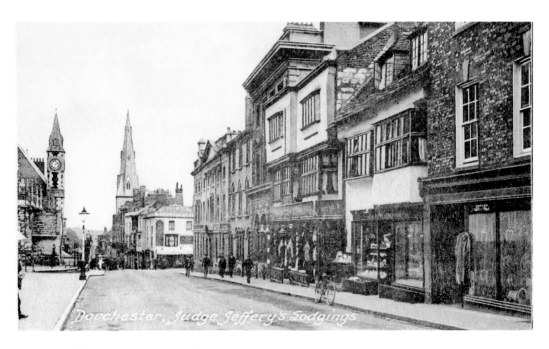

High West Street, South Side, *c.* 1900

There are a variety of fine buildings on the south side of High West Street past the junction with Trinity Street in both the past and present photographs. The best known is Judge Jeffreys' Lodgings, so called because it is thought that the ruthless and vindictive judge who tried many who took part in the Monmouth Rebellion in the 1680s stayed here. The three-storey frontage dates from the seventeenth century.

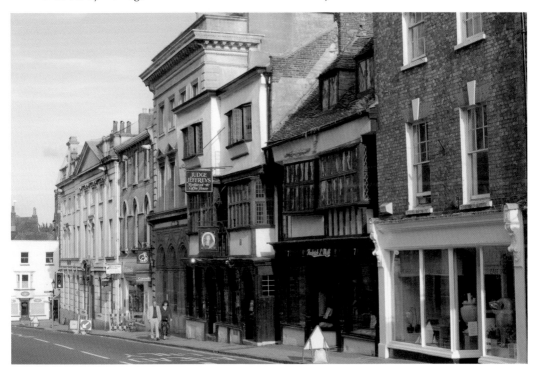

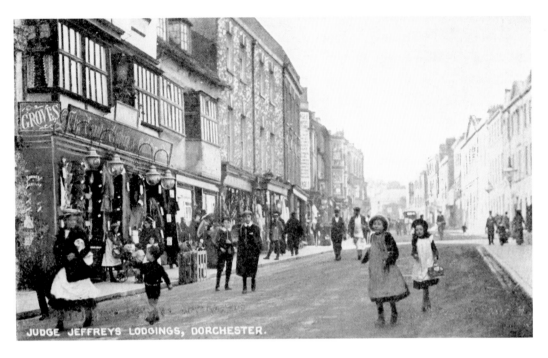

Judge Jeffreys' Lodgings, *c.* 1900

And now we look from the other direction, with part of the frontage of Judge Jeffreys' Lodgings on the left. In a time of little traffic, people were comfortable walking in the road as well as on the pavement.

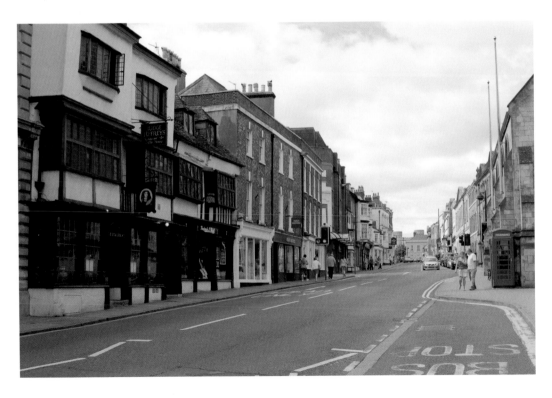

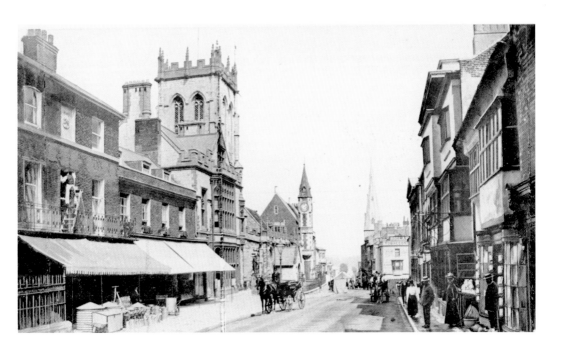

High West Street, North Side, *c.* 1905
This view looks towards the side of High West Street that is opposite Judge Jeffreys' Lodgings. Note the goods for sale in the street itself beneath large awnings.

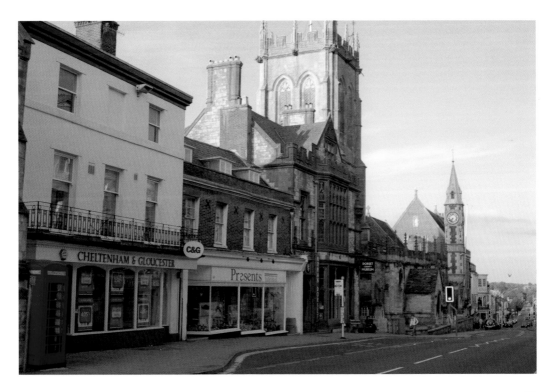

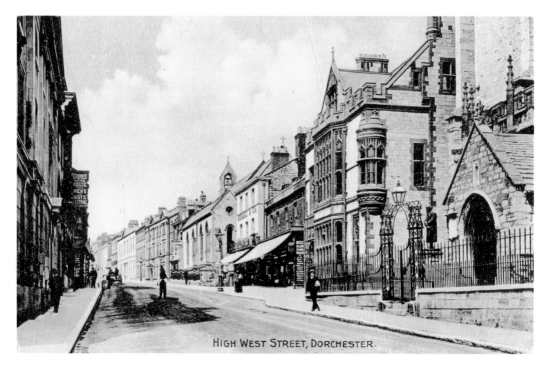

HIGH WEST STREET, DORCHESTER.

Dorset County Museum, c. 1905
Now we are looking back up High West Street with Dorset County Museum prominent in the view. This was built between 1881 and 1883 and is designed in the style of a late medieval building. The golden stone used for the more decorative parts of the structure comes from Ham Hill in Somerset.

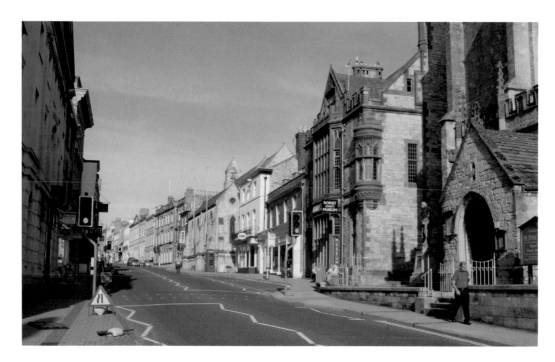

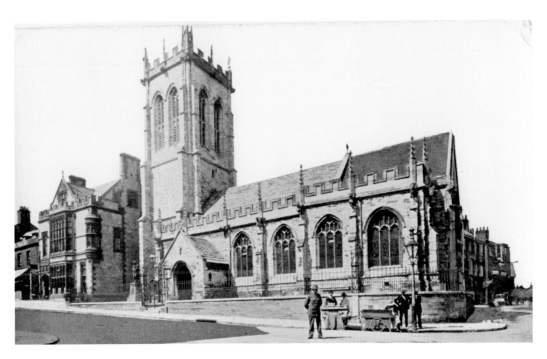

Dorset County Museum and St Peter's Church, c. 1910
Shifting viewpoint slightly gives us this view of Dorset County Museum and St Peter's church. Between the two buildings we see the statue of the Dorset dialect poet William Barnes. He lived from 1801 to 1886, running a school in Dorchester for much of his life and spending his latter years as rector out at Winterborne Came. This statue was erected two years after his death.

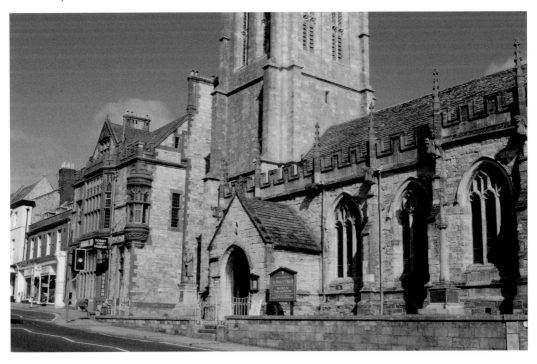

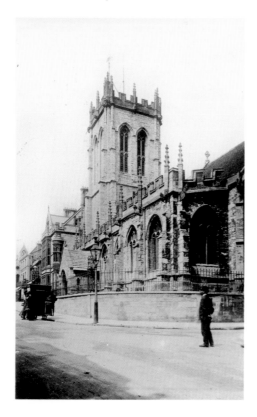

St Peter's Church, *c.* 1905
Here is a corner view of St Peter's church. It has a Norman south doorway and much of the rest, including the tower, dates from the fifteenth century. In fact, it was one of only a few buildings to survive a major fire in the town that occurred in 1613. The young Thomas Hardy worked as an architect's apprentice on restoration work to the church in the 1850s.

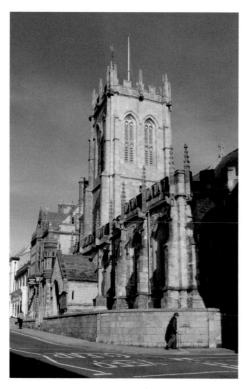

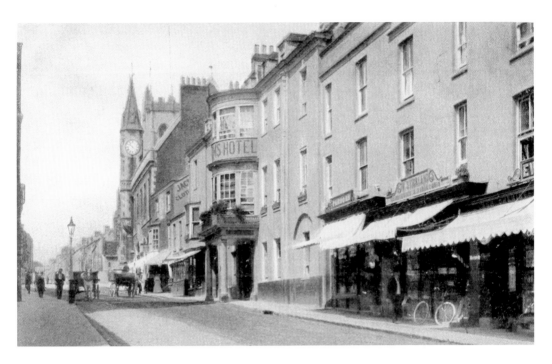

High East Street, *c.* 1900

Next we head down High East Street and looking back up the hill the King's Arms is on the right side. Its projecting porch with bow windows on the two storeys above is a distinctive feature of any view of this part of the street. These features were added to the building in the early nineteenth century.

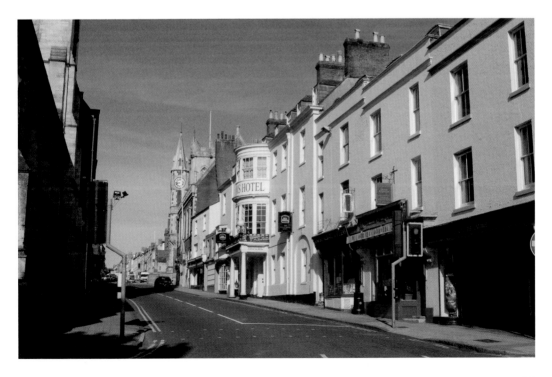

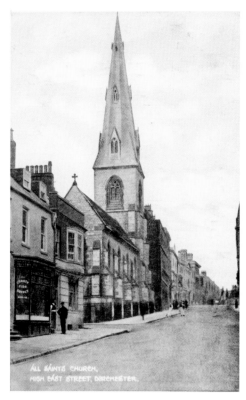

All Saints Church, High East Street, Dorchester.

All Saints' Church, *c.* 1900

On the corner of High East Street and Church Street is All Saints' church, which was rebuilt in the 1840s under the direction of Benjamin Ferrey. It was still a church when the older photograph was taken, but it is now an artefact store for the County Museum. Compare the left sides of both pictures and you will see that the house on the end is no longer there — it was demolished when the junction with Church Street was widened around 1980.

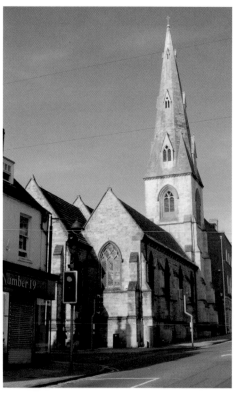

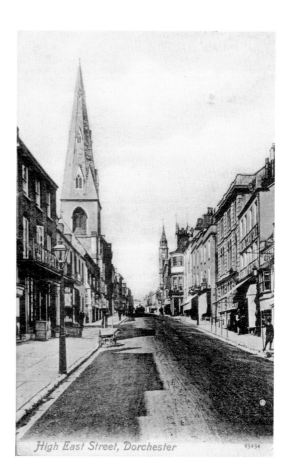

High East Street, c. 1905
Now a look back up the hill from
further down High East Street.
I had to be up early on a Sunday
morning to see it with so little
traffic, but I suspect the other
photographer had a much wider
choice of time.

High East Street, Dorchester 25234

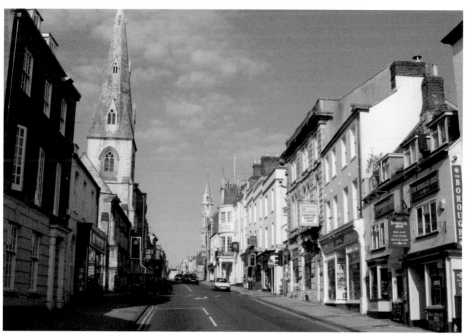

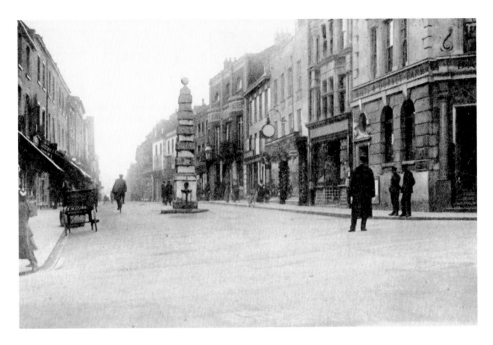

Cornhill and South Street, *c.* 1905

We now return to the corner beside St Peter's and look down Cornhill and South Street. The town pump is in the centre of Cornhill. It is made of Portland stone and was erected in 1784, supplying water for over a century. What is now Lloyds TSB Bank on the corner on the right was the Wilts and Dorset Bank in the early photograph — this company was taken over by Lloyds in 1914.

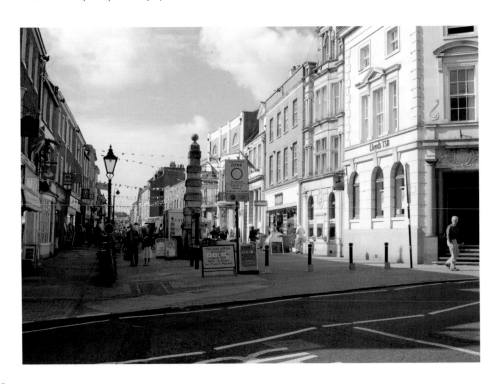

Cornhill and the Corn Exchange *c.* 1910
Going into Cornhill to look at the town
pump from the other side, we also see
beyond it the chancel end of St Peter's
and a building we have seen in several
previous views but that I have yet not
mentioned — the Corn Exchange. This
was constructed in 1847/8 by Benjamin
Ferrey, who then added the turret-
cum-clock tower in 1864 and the main
entrance in 1876.

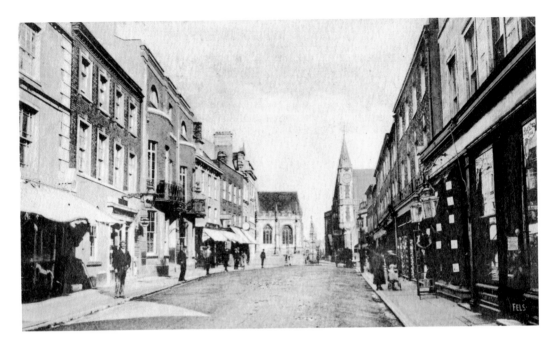

Cornhill, *c.* 1910

These shots are taken from further down Cornhill and looking in the same direction as the previous pair. The old Antelope Hotel, which together with its outbuildings at the back was converted into the Antelope Arcade in the 1980s, is a prominent feature in this view. The upper storeys of many buildings in Cornhill and South Street have changed little in the past century. However, look at the greater changes at ground floor level, like, for instance, at what is now Boots to the left of the Antelope.

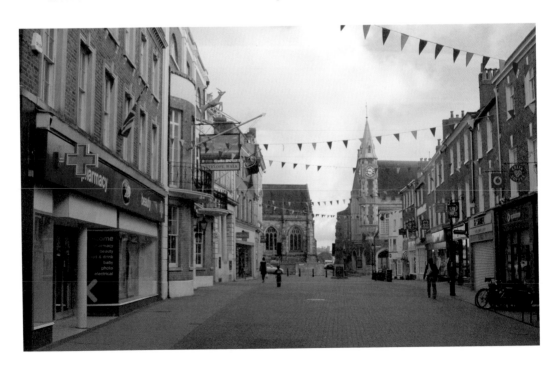

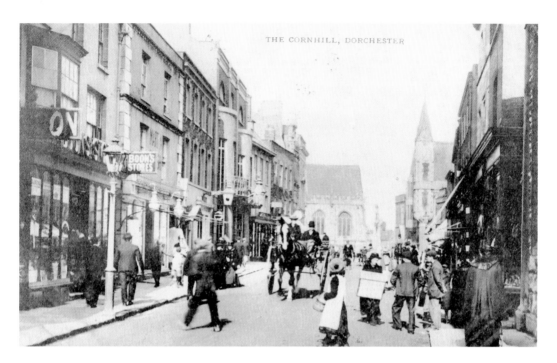

THE CORNHILL, DORCHESTER

Cornhill *Continued, c.* 1900

A similar view just a shop or two further down Cornhill. The sign in the old photograph is pointing at Boon's Stores, a grocer's on the right of the shot. You can just make out the opening into Durngate Street next to it, with the edge of the Methodist chapel that was demolished in 1981 on the extreme right edge.

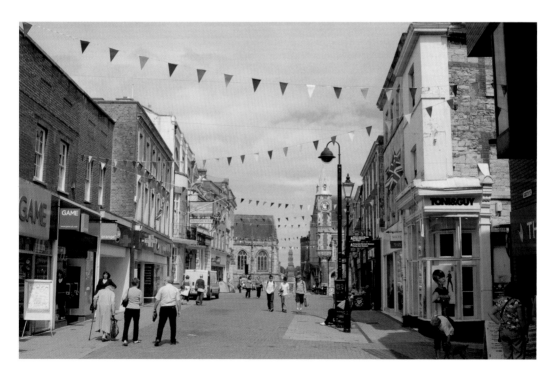

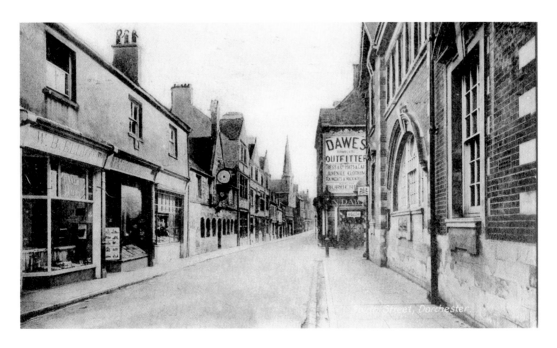

South Street, *c.* 1920

This view is a fair bit further along into South Street now, and is looking in the opposite direction. The building that from its construction in 1904 until a few years ago was the town's post office is on the right. On the corner beyond, Dawes is advertising on the wall above the shop. The business is described as a 'gentlemen's outfitter, hatter, hosier and merchant tailor' in a contemporary trade directory.

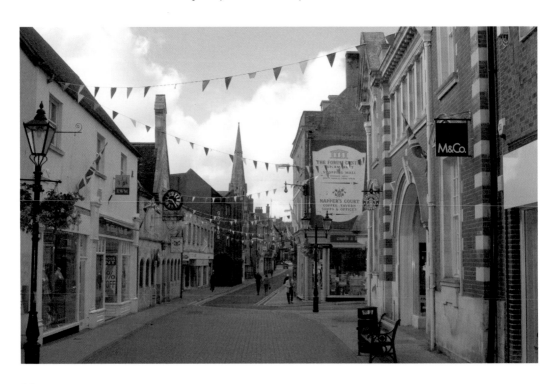

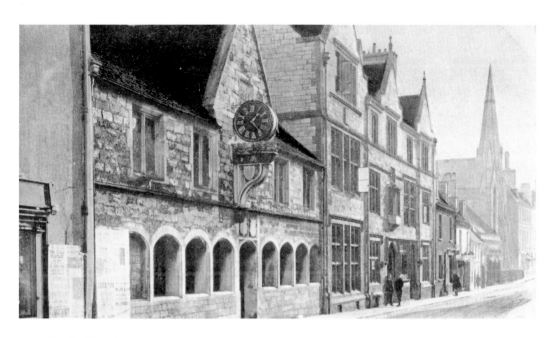

South Street, c. 1900

Above is a close-up of two buildings that can be seen opposite Dawes' establishment in the older of the last pair. On the left is Napper's Mite, built in 1615 as almshouses for ten poor men according to the will of Sir Robert Napper of Middlemarsh. As my photograph shows, the rather splendid building on the right in the older view has disappeared. It was the Dorchester Grammar School, built in 1879 and demolished in the late 1960s to make way for the Hardye Arcade.

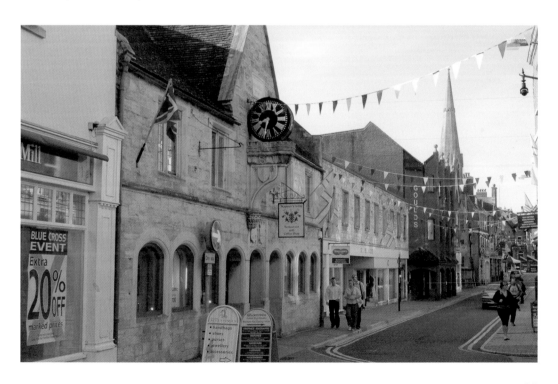

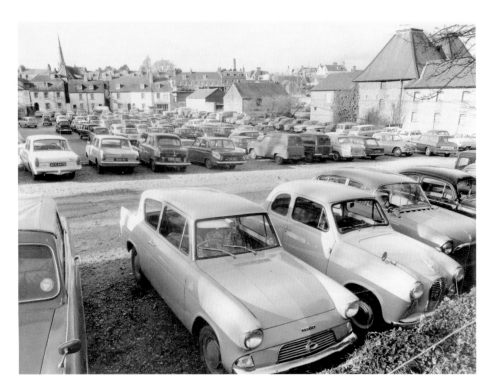

Charles Street, 1966/7

Now for two views using some relatively recent 'old' photographs that show an area of the town that has changed quite a lot, that around Charles Street. In the 1960s there were already car parks here, although they occupied a smaller area than today. This view looks across the Old Market car park in the direction of South Street. The large building on the right in the older view is the Malthouse, although in its latter days it was a store for Lock's Seeds. As the modern photograph shows, it has since been demolished, as have most of the houses beyond the car park in Charles Street, some during the redevelopment of the Hardye Arcade.

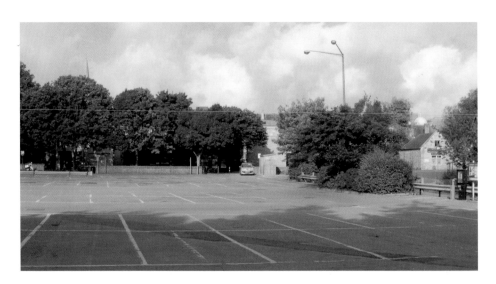

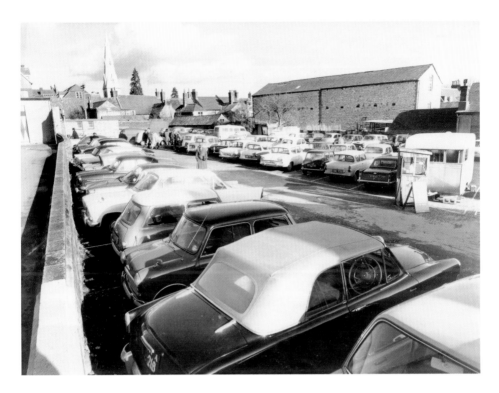

Charles Street *Continued*, 1966/7

These photographs were taken in what is now the corner of the larger car park. The church tower is All Saints' in High East Street, but otherwise the background is much changed as the buildings around what used to be called Greyhound Yard were demolished in the early 1980s. They were replaced by the Waitrose supermarket development, which included more car parking space, this time underground.

Dorset County Hospital, *c.* 1910

The site of the old Dorset County Hospital is back across to the west of South Street. This is the original building, erected in 1840 to the design, once again, of Benjamin Ferrey. The hospital site expanded greatly over the years until finally in the 1980s a replacement was built on a new site between Bridport Road and Damers Road. The old site was redeveloped in the 1990s, much of it for housing, and historic buildings such as this one were saved and incorporated in the development.

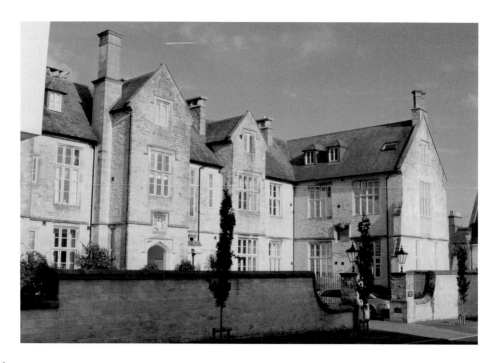

The defences of the Roman town of
Durnovaria, Dorchester's predecessor,
survived in fairly good condition until
the first decade of the eighteenth century,
when they were made into boulevards
following a fashion recently introduced
from the Continent. Almost all of the
stone wall that topped the inner bank was
demolished, the banks themselves were
smoothed out and the ditches outside
were filled in, then trees were planted on
either side of a path.

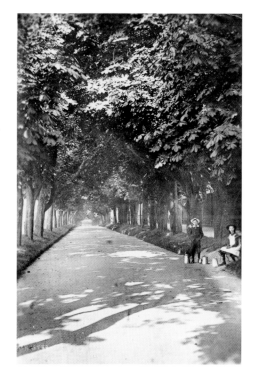

South Walks, *c.* 1910
We begin our tour around the Walks, as
these boulevards are known, near their
south-east corner. This view looks west
along South Walks, not far from where
Elizabeth Frink's Dorset Martyrs sculpture
now stands at the junction with Icen Way.

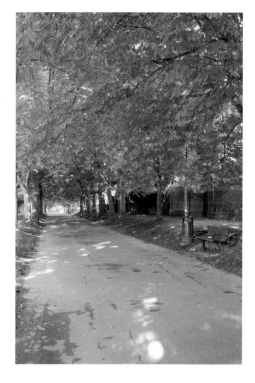

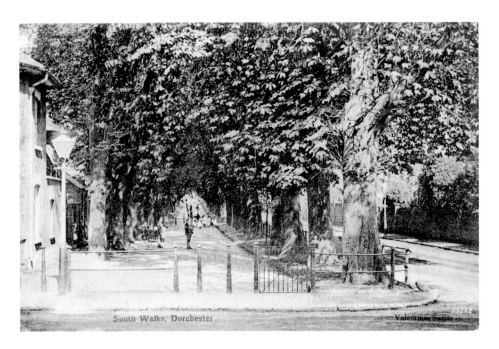

South Walks, Dorchester

South Walks *Continued, c.* 1905

From the end of South Street, we now look back along South Walks towards our starting point. The Edwardian photograph shows that the Walks once had fences and had to be entered through gates. The most obvious difference between the two photographs, though, is the war memorial, which was erected in 1921 to commemorate the dead of the First World War.

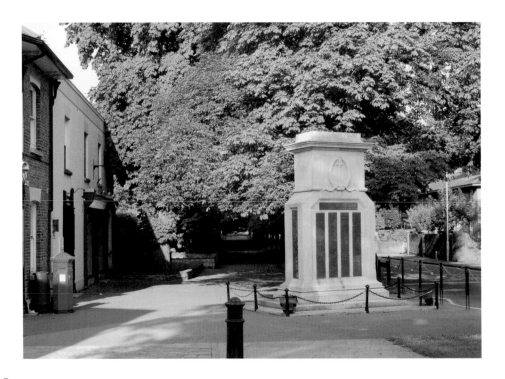

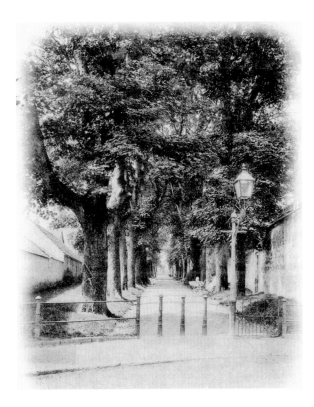

Bowling Alley Walk, c. 1900

Although you could argue that it is really just the western end of South Walks, the section past Trinity Street is called Bowling Alley Walk. These views look along it from Trinity Street.

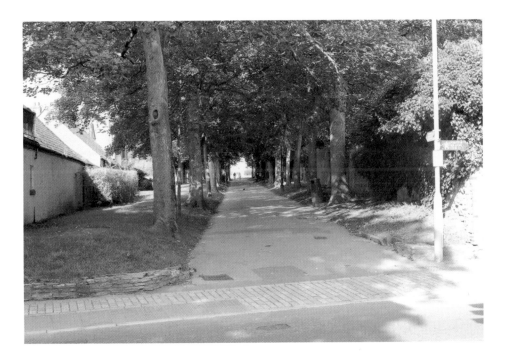

Bowling Alley Walk and West Walk, *c.* **1910**

This is the south-west corner of the Walks, where Bowling Alley Walk turns right and becomes West Walks. The clock tower in the Borough Gardens (of which more later) can be seen on the left.

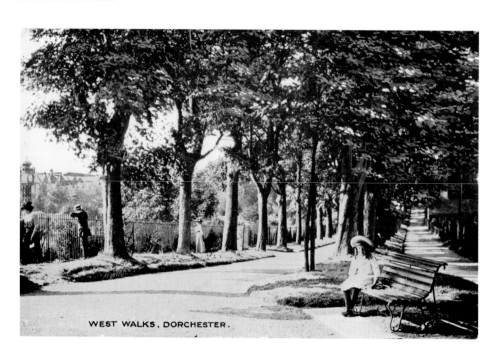

WEST WALKS, DORCHESTER.

West Walks, *c.* 1900
And this is the longer stretch of
West Walks, looking back towards
the corner in the last view from
not far short of the junction with
Princes Street.

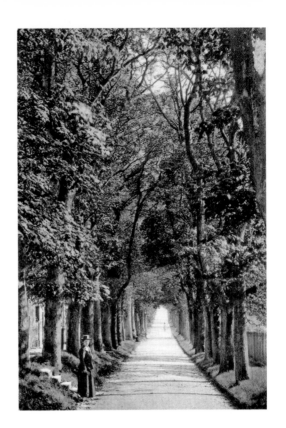

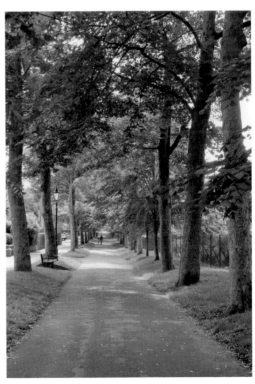

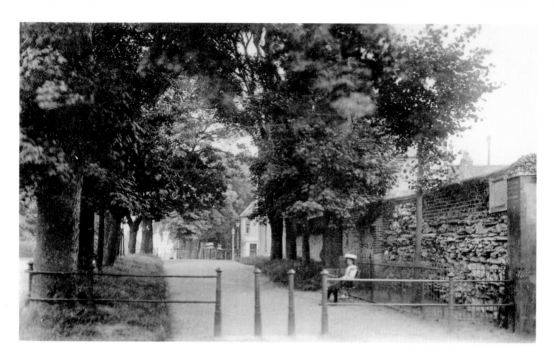

West Walks and the Roman Wall, *c.* 1905

We now turn around and look across Princes Street at the section of West Walks that runs up to Top O'Town and which includes the only surviving section of Roman wall. Again, there is a fence here in the old view, with bollards instead of a gate.

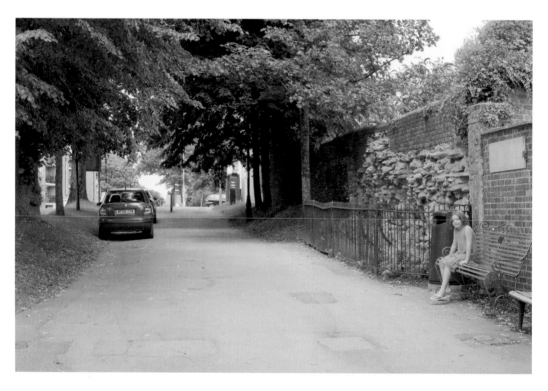

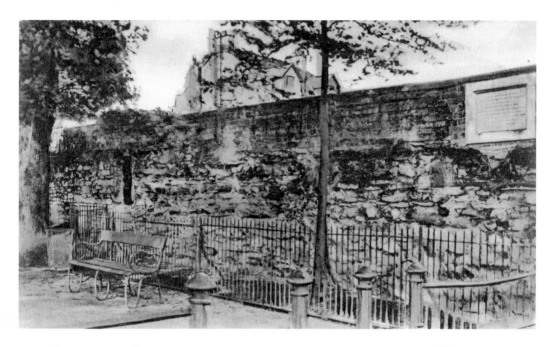

The Roman Wall, c. 1900

Here is a close-up view of the wall in the previous pair of photographs. The Roman defences were first constructed in the early second century AD, but consisted of banks and ditches only. It was a further 200 years before a wall was added to the inner bank for extra security. When the rest of the wall was demolished to make way for the boulevards, this short section survived because it was a property boundary.

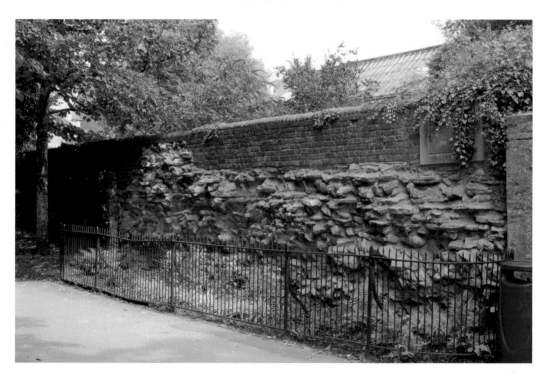

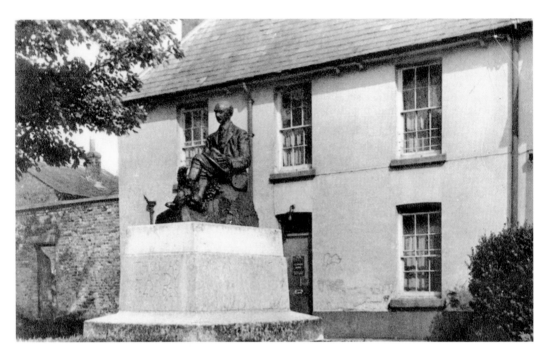

Thomas Hardy Statue, *c.* **1935**
On the opposite side of Top O' Town we find the statue of Thomas Hardy, which was erected in 1931, three years after the novelist and poet's death.

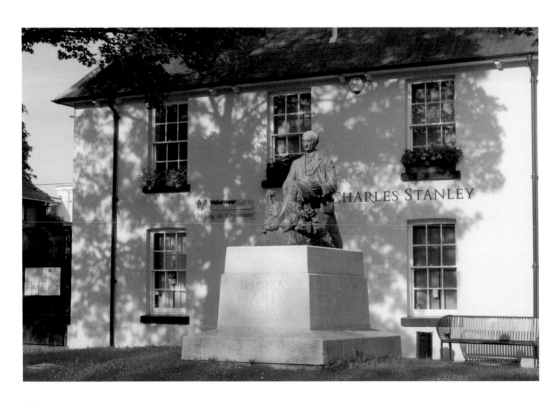

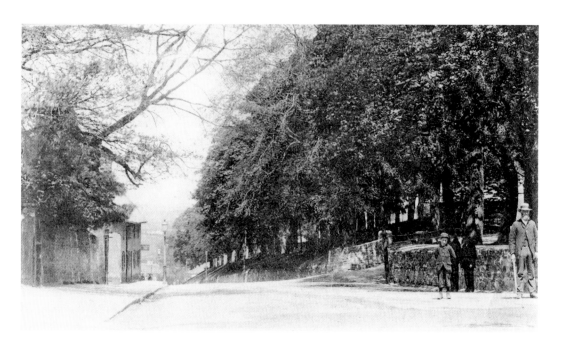

The Grove, c. 1900

Taken from a short distance beyond the previous views, these look down The Grove, which is the northern end of the west side of the Roman defences. Those defences were not levelled here as elsewhere, and an idea of their original size can be gained, with the boulevard on the top of the inner rampart and the road probably running in one of the ditches. The people in the older photograph are standing to the right of the entrance to the grounds of Colliton House, in which County Hall would be built in the 1930s.

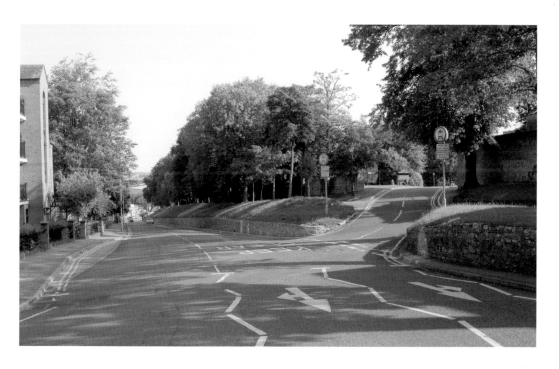

THE BOROUGH GARDENS

The Borough Gardens were first laid out in the 1890s, although many of their distinctive features were not added until around 1905, when the bandstand was erected and Charles Hansford donated the clock tower that still bears his image. I make no apologies for including seven views of them here, especially since although the general layout has not changed a great deal, the old images show a different 'landscape' of newly-planted vegetation, with views of the houses around that today are obscured by the mature trees.

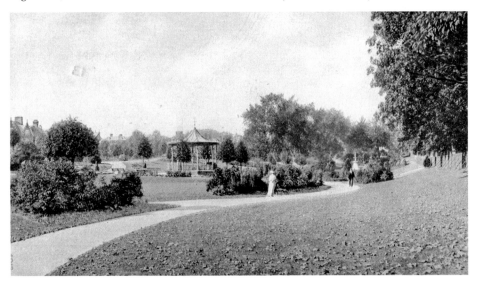

Borough Gardens, 1909
These views were taken from similar locations just inside the entrance near the corner of Bowling Alley Walk and West Walks. Above is a postcard sent in 1909, so the photograph must have been taken between 1905 (when the bandstand was erected) and 1909.

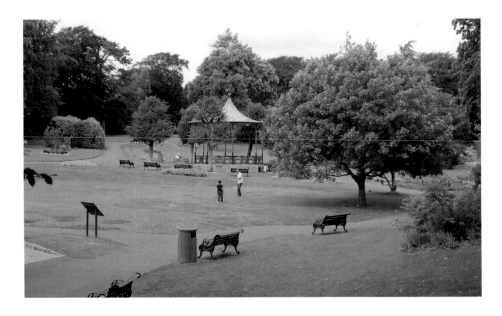

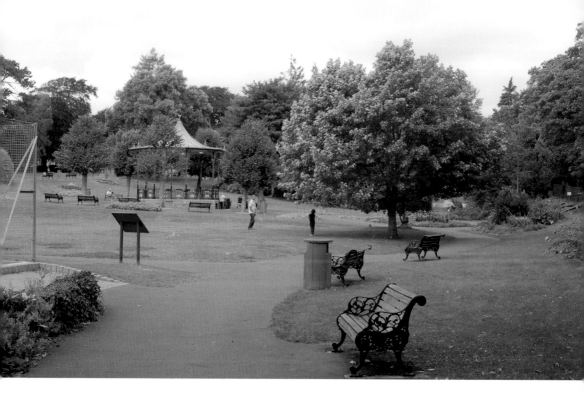

Borough Gardens

These views were taken from a similar spot to the previous pair. Below is a postcard sent in 1914, and though postcards were often sold for a number of years after the images were first taken, I think this photograph is a few years later than the one on the previous page. The seat on the right has been added, and the trees and shrubs seem more mature.

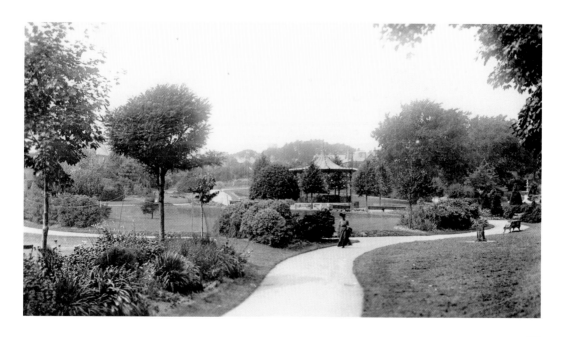

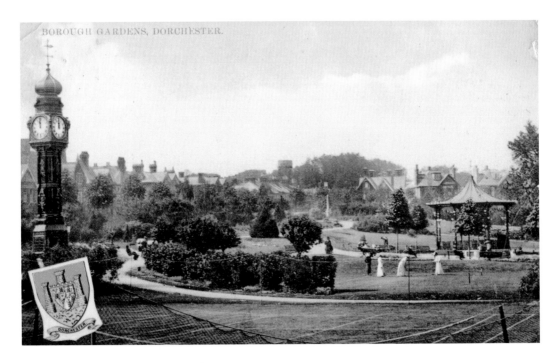

Clock Tower and Bandstand, *c.* 1905

This and the next two older views are all postcards sent within three years of the erection of the clock tower and bandstand. It is tempting to see them as commemorative editions for the improvement works in the Gardens. This view shows the clock tower and bandstand across the corner of the tennis courts.

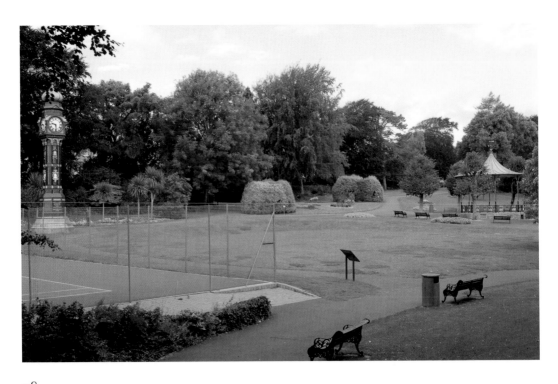

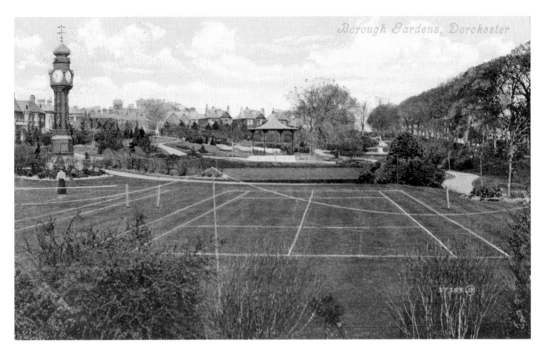

The Tennis Courts, c. 1905
Now we move to the back of the tennis courts and again look towards the clock tower and bandstand.

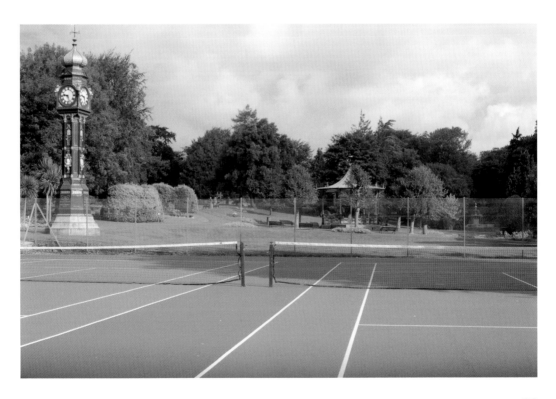

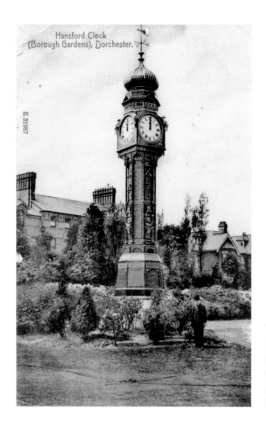

Hansford Clock
(Borough Gardens), Dorchester.

The Clock Tower, c. 1905

Pictured are close-up views of the clock tower. The one above was quite possibly taken just after the tower was erected, and I wonder if the person is the donor Charles Hansford himself?

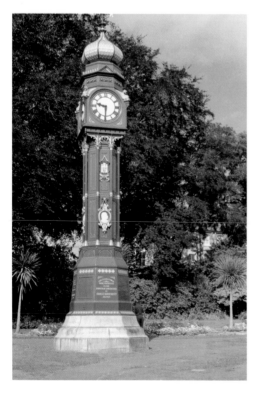

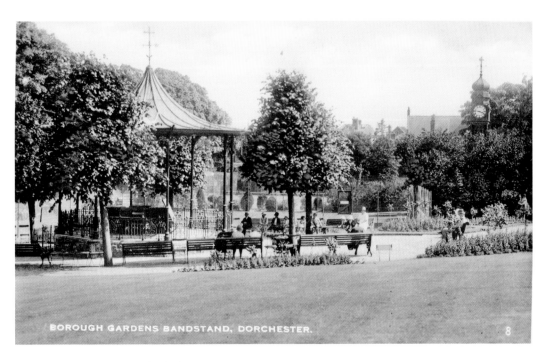

BOROUGH GARDENS BANDSTAND, DORCHESTER.

The Bandstand and Clock Tower, *c.* 1920
Now we head across Borough Gardens and take a look at the bandstand and clock tower from the opposite side.

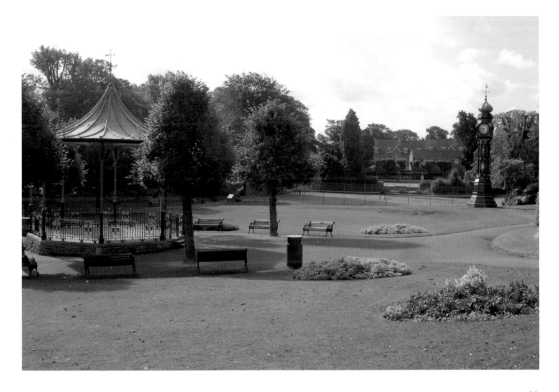

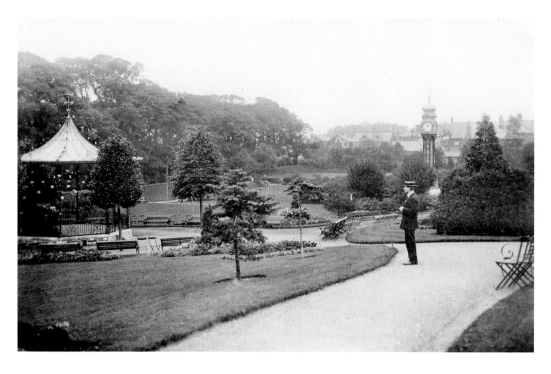

The Bandstand and Clock Tower, *c.* 1910
Before we leave Borough Gardens here is one final view. It is similar to the previous one but has been taken from a little further up the slope.

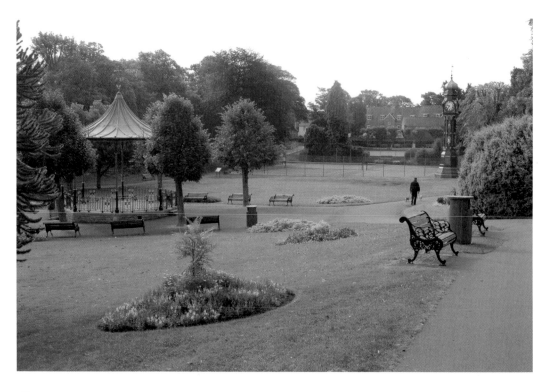

FURTHER OUT

We will now abandon our relatively orderly progress through the town to look at a few sights that are outside the Walks.

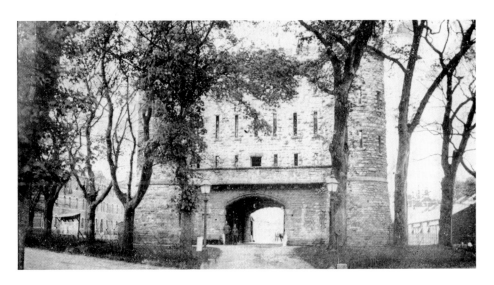

The Keep, *c.* 1895

The Keep is beside Bridport Road not far from Top O' Town. It was constructed in 1876-7 as the gatehouse of the barracks of the newly formed Dorsetshire Regiment, and today it is the home of the Military Museum of Devon and Dorset. In the older view you can see barrack buildings in the background on either side. Today, those on the left have been replaced by the tax office, while those on the right have been taken over by the post office.

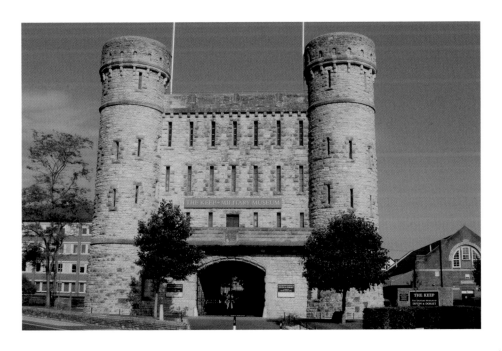

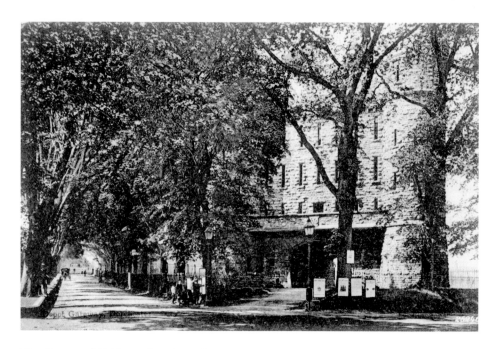

The Keep and Bridport Road, *c.* 1895

A change of angle shows us one of the avenues of trees that lined the main roads out of the town. Legend has it that they were planted by French prisoners captured during the Napoleonic Wars a hundred years before this photograph, but some at least date from later in the nineteenth century. Some of these avenues survive in part, but most of this one was cut down around 1900.

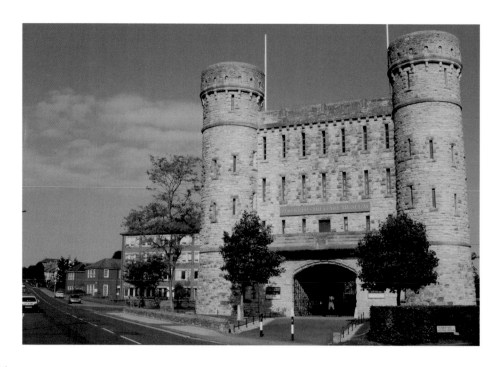

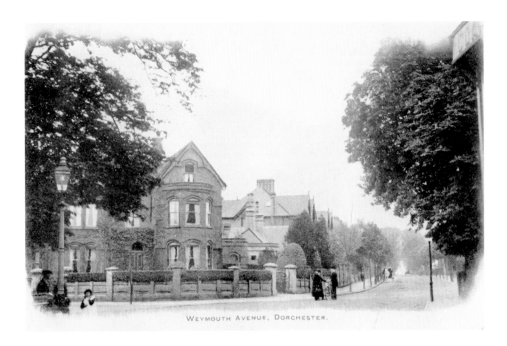

WEYMOUTH AVENUE, DORCHESTER.

Weymouth Avenue, *c.* 1905

This view looks down Weymouth Avenue from the junction of South Walks, South Street and Trinity Street, close to the south gate of the Roman town. From the 1870s onwards, the Duchy of Cornwall released land on the south side of the town for development, and many elegant town houses such as these were built, as well as the Eldridge Pope brewery which is just out of shot.

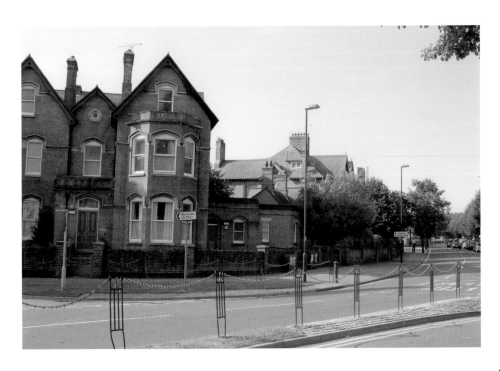

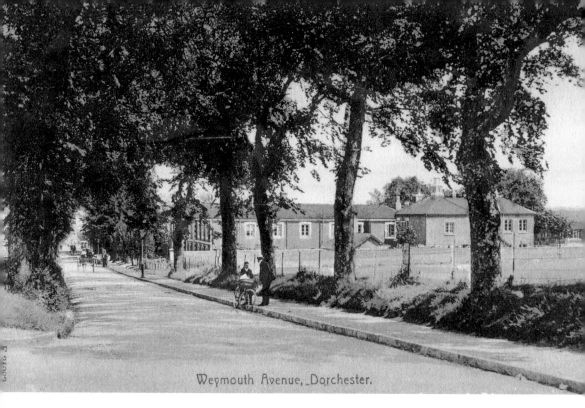

Weymouth Avenue, Dorchester.

Weymouth Avenue, *c.* **1900**
We next head further down Weymouth Avenue and look back across the road and the corner of the grounds of Maumbury Rings towards the police station.

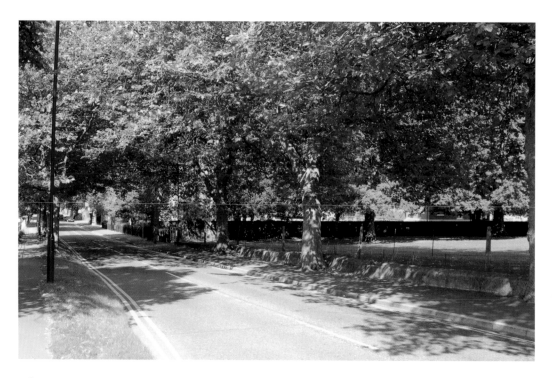

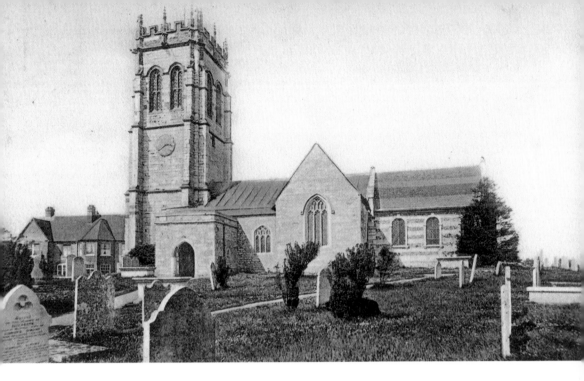

St George's Church, *c.* 1900

Now over to the east side of the town. Although Fordington has long been absorbed into Dorchester, St George's church and the green next to it help to retain a village atmosphere. Unlike the other churches we have seen, this one has undergone a noticeable change. In 1906, plans to extend the nave of the church and to add a new chancel were agreed. Work began in 1907 and continued until after the First World War. I had to take my photograph from a different angle from the earlier one in order to show the size of what is now a rather long church.

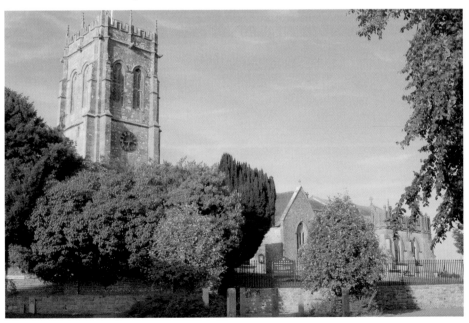

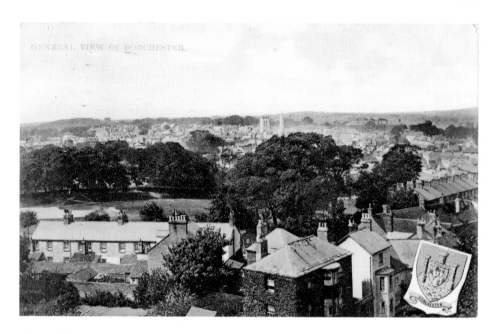

GENERAL VIEW OF DORCHESTER.

View of the Town, *c.* 1920

The photograph above was taken from the tower of St George's church around 1910 and looks across the town with the towers of St Peter's and All Saints' in the centre. The other was taken from rather higher up, with St George's itself just to right of centre, and the main part of the town beyond.

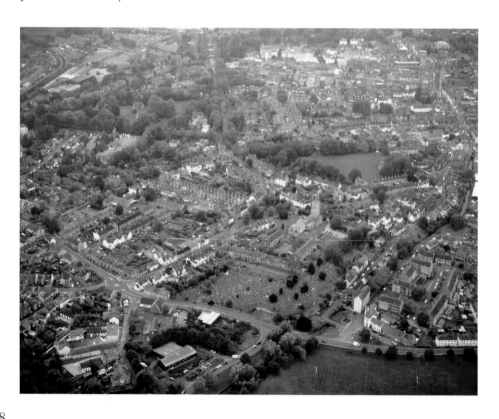

ARCHAEOLOGICAL REMAINS

Dorchester is deservedly renowned for its archaeological remains, so here we will look at some of the best-known sites in and around the town.

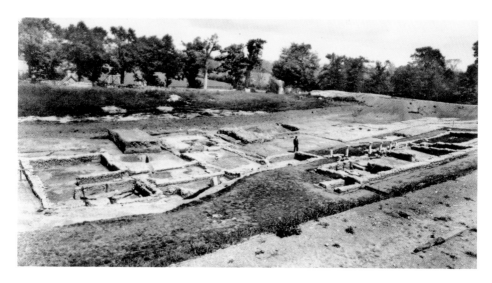

The Roman Town House, c. 1938

The Roman Town House was found during archaeological excavations carried out in the later 1930s in what had been the grounds of Colliton House in advance of the building of County Hall. The main phase of excavation of this Roman building took place in 1937, revealing a house that was in use between the second and fifth centuries AD. Spoil heaps from the construction of County Hall can be seen in the background on the right in the older photograph. Over the last decade or so the County Council has constructed a cover building over one range of the Roman Town House and added new interpretation.

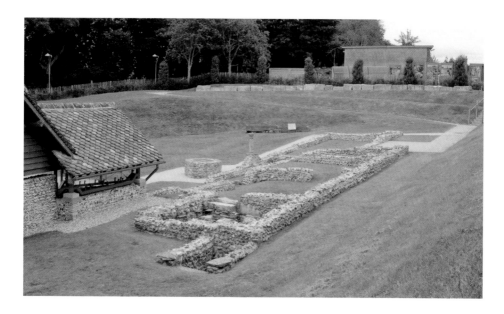

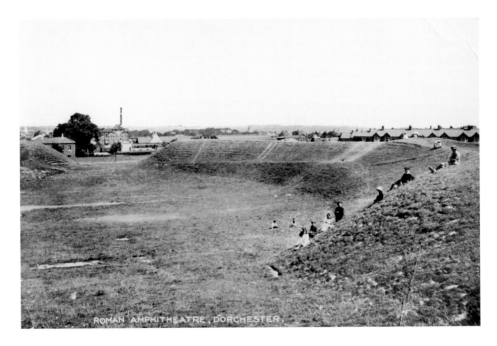

Maumbury Rings, *c.* 1910

Maumbury Rings is a much-adapted ancient monument beside Weymouth Avenue. It was constructed as a henge around 2500 BC, and then adapted by the Romans — quite possibly by an army unit that was stationed here before the town of Durnovaria developed — into an amphitheatre. In the early 1640s during the English Civil War it was further adapted as a fort by the town's Parliamentarian defenders. Since then it has been used for executions, celebrations of Royal Jubilees and, more recently, for the staging of plays.

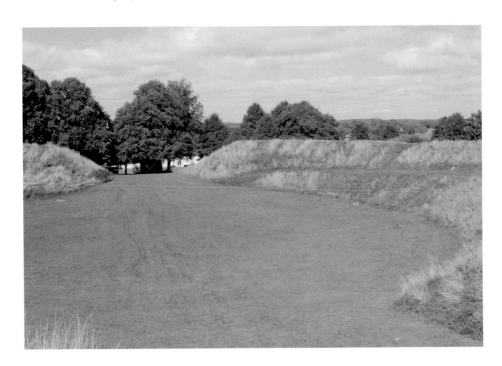

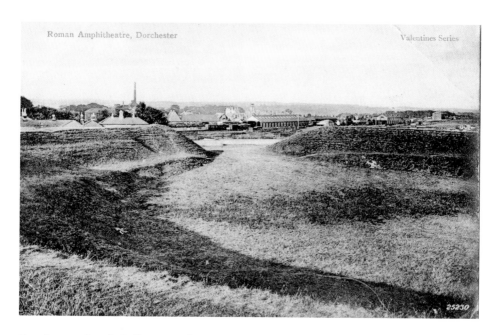

Dorchester South Railway Station, *c.* 1910

Although this old photograph of Maumbury Rings is similar to the previous one, I have included it because there is a good view of the old Dorchester South Railway Station. Since the railway was originally intended to continue west towards Axminster rather than south to Weymouth, the station was constructed on an east-west alignment. After over a century of trains from Weymouth having to reverse into the station, a new platform was built in 1970. My photograph is taken from the opposite side of Maumbury Rings, to give a better view of the present Dorchester South station.

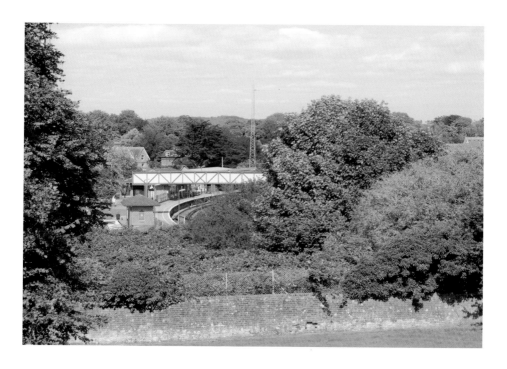

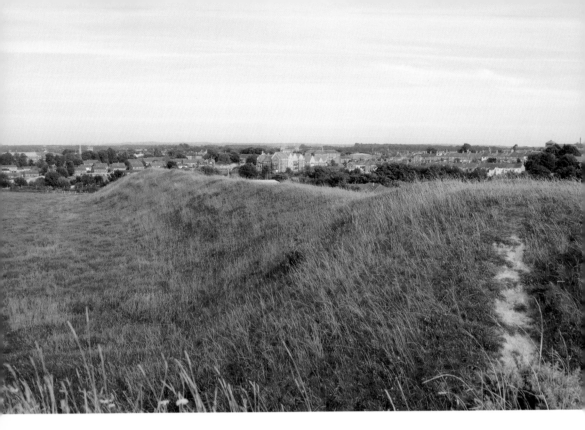

Poundbury Camp, *c.* 1910

Poundbury Camp is an Iron Age hillfort on the north-west edge of Dorchester. The ground rises gradually as you head out from the town centre and there are commanding views from the camp across the Frome valley and much of the land around. These views look eastwards along the south rampart of the hillfort from the south-west entrance. Erosion scars are not just a recent problem!

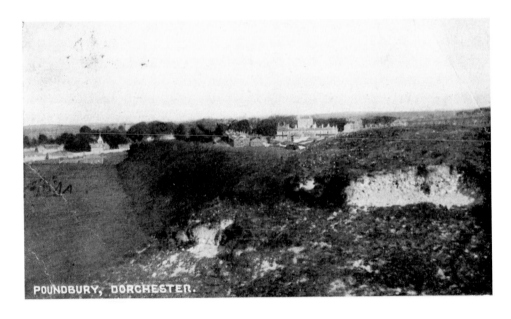

POUNDBURY, DORCHESTER.

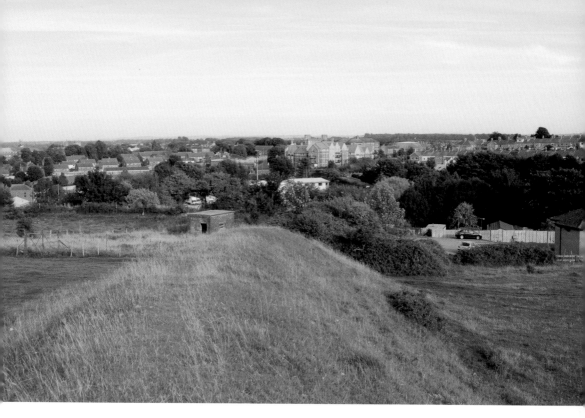

Poundbury Camp *Continued, c.* 1910

These views are taken from further along the south rampart and show the view back into the west side of Dorchester. The early photograph shows the extensive army barracks (the tallest building is The Keep), now largely replaced by housing and industrial estates, and you can see Poundbury Road running along a raised causeway.

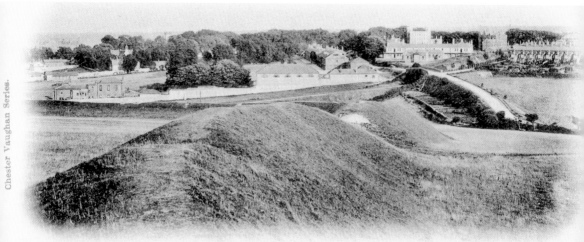

General View from Poundbury, Dorchester.

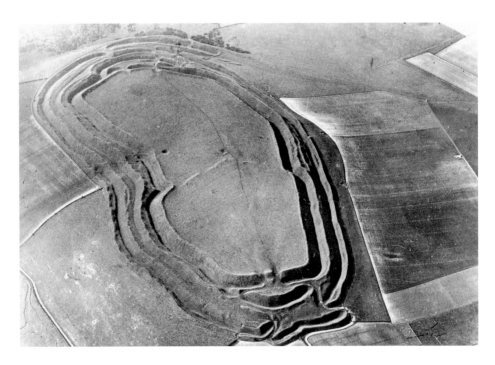

Maiden Castle, c. 1930

Maiden Castle lies a couple of miles south-west of the town centre and is one of Britain's largest Iron Age hillforts. It is also often described as the 'best' because of its size, the views it commands and the excellent preservation of its spectacular ramparts. Its reputation was enhanced by the excavations that took place on the site in the 1930s, under the direction of Sir Mortimer Wheeler. This was when much of the site's history was discovered and brought Maiden Castle (and its excavator) a great deal of publicity. These aerial views were taken from the east side of the hillfort.

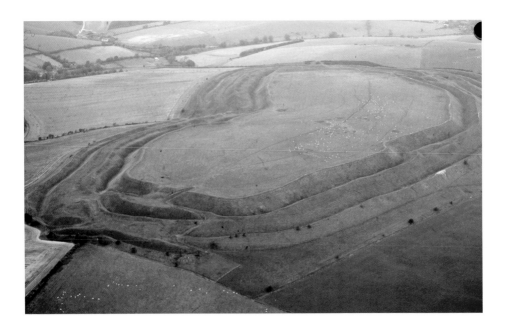

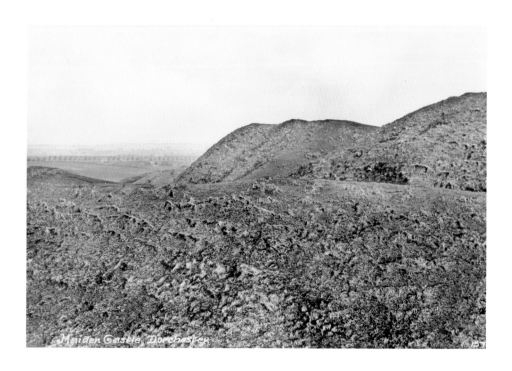

Maiden Castle, Western Entrance, c. 1910

I must confess that I cannot work out exactly where the older photograph was taken, but it must have been somewhere near the western entrance, which is where the modern path from the car park comes into the hillfort.

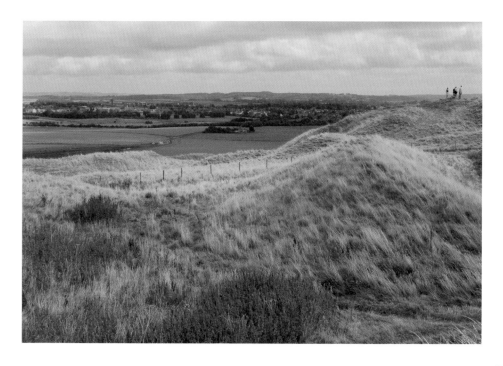

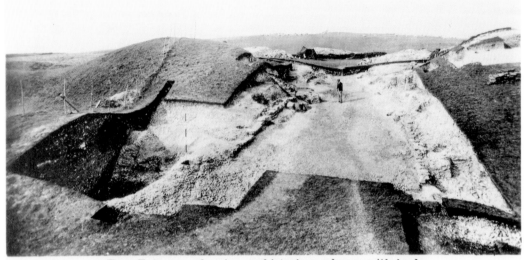

East Entrance, showing prehistoric roadway, with kerbs

One of Wheeler's Trenches, *c.* 1937
This is one of Wheeler's trenches, opened to examine part of the hillfort's eastern entrance.
English Heritage carried out further excavations at Maiden Castle in the 1980s.

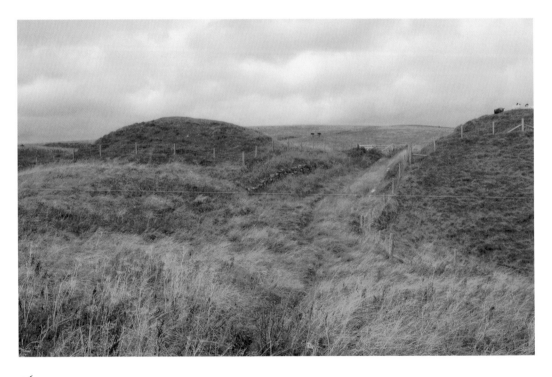

THE FROME VALLEY AND ITS WATERMEADOWS

The valley of the river Frome sweeps along on the north side of the town. From the eighteenth century onwards it was filled with watermeadows, a system of controlling the flow of the river that fertilised the land and encouraged an early growth of grass. This system survived in use until soon after the Second World War, and some of the gates that controlled the flow and bridges used by the 'drowners' who managed the watermeadows can still be seen, especially just east of the town towards Stinsford.

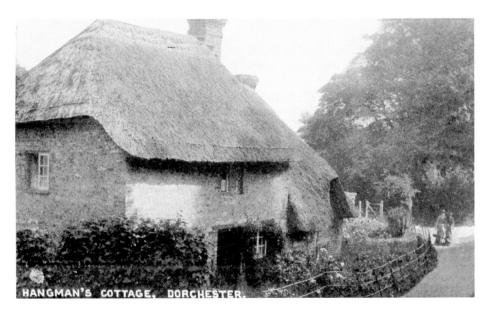

Hangman's Cottage, c. 1910

One of the best ways to reach this area from the town is past Hangman's Cottage, off Northernhay on the far side of County Hall. It has been said that this place got its name because Judge Jeffreys' executioner lived here, but in reality it was presumably the home of Dorchester prison's hangman.

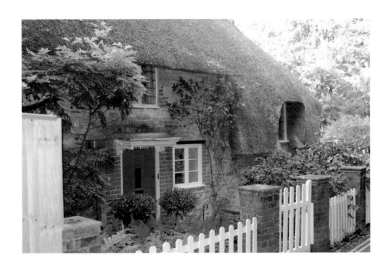

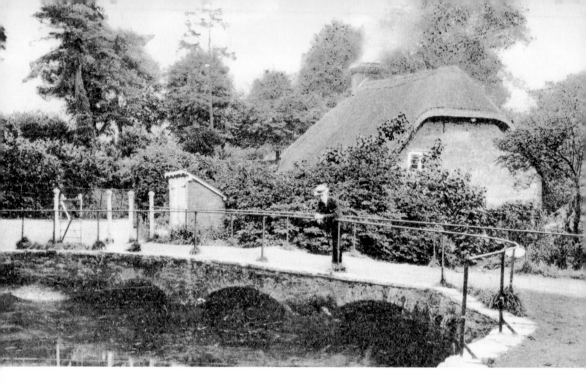

Hangman's Cottage and the Millstream, *c.* 1905
Here is Hangman's Cottage seen from the other side, together with the bridge over the Millstream. The latter is one of the channels of the river Frome and got its name because it served a mill that used to be at the bottom of Friary Hill, a few hundred yards downstream from this spot.

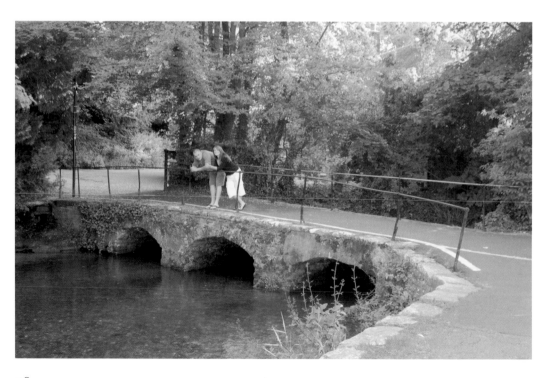

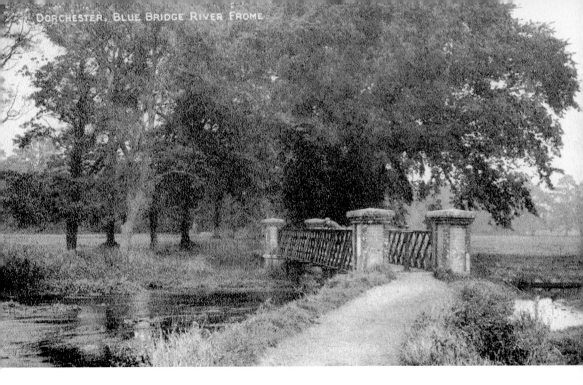

Blue Bridge, *c.* 1910

A path leads north from Hangman's Cottage across the watermeadows to the hamlet of Frome Whitfield. A few hundred yards along that path another channel of the Frome is crossed by Blue Bridge, which was erected in 1877 and restored in 2002. The early view is taken from the Dorchester side, but from this spot the bridge is now largely obscured by a tree, so my photograph is taken from the opposite bank.

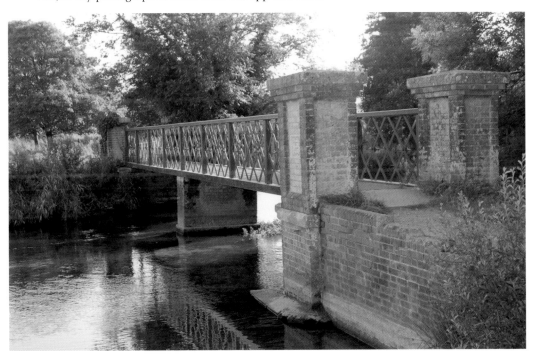

Path to Frome Whitfield, *c.* 1905
It took me some time to work out where this rather pleasant view was taken. In fact, the location is only a hundred yards or so further along the Frome Whitfield path from Blue Bridge and, fortunately, the view has not changed much.

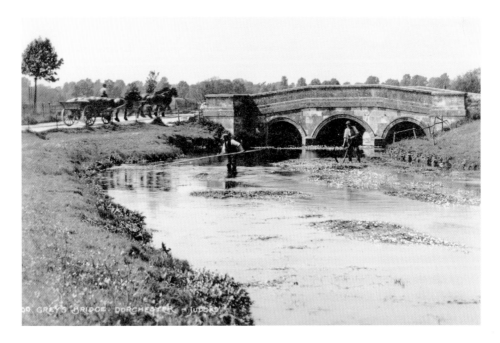

Grey's Bridge, c. 1910

Grey's Bridge carries London Road across one of the channels of the river Frome. It was built in the 1740s by the owner of Kingston Maurward, Mrs Laura Pitt, and bears her maiden name. She also had the road moved to its present alignment — previously the route east had gone through Fordington. The views are taken from the north side of the bridge, close to where there is still a footpath, although the exact location is rather overgrown in summer, particularly since people are no longer sent into the river to clear it!

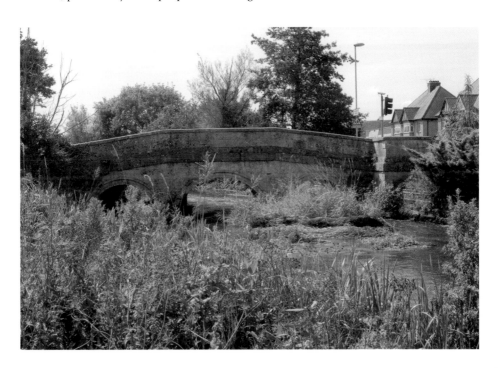

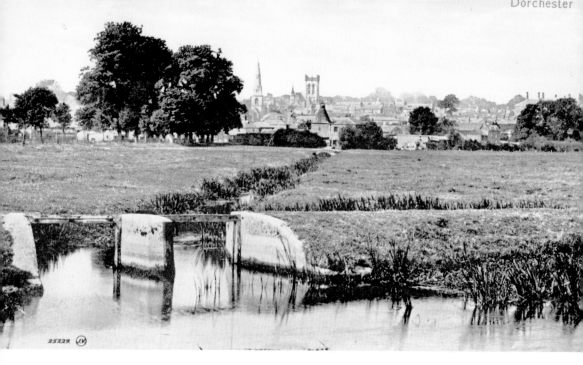

Watermeadows and View of Dorchester, *c.* 1920

This is the first of two views taken not far from Grey's Bridge. The early view seems to show working watermeadows, with straight channels cutting across the field to a sluice gate by the river in the foreground. Today the channels have been filled in, and the sluice gate has been replaced by a field gate. We also get a good view of the town, with the spire of All Saints' and the tower of St Peter's prominent on the skyline. The trees on the left have been replaced by the Casterbridge Industrial Estate.

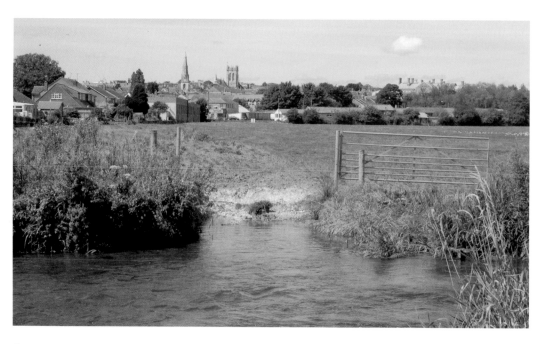

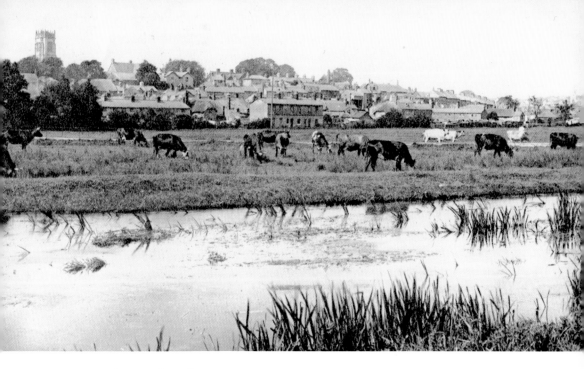

Watermeadows and Fordington, *c.* 1900

This shot of the watermeadows looks more towards Fordington — the tower of St George's church is on the left. The early photograph shows the houses of Fordington extending down to London Road. Today these are obscured by the houses built on the north side of that road.

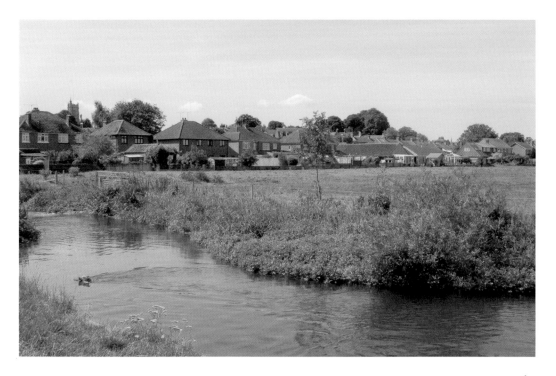

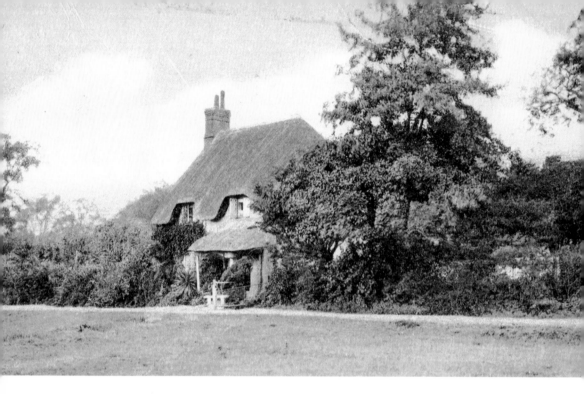

Three Bears Cottage, *c.* 1930

A short distance past Grey's Bridge a path leaves the road and heads across the watermeadows in the direction of Stinsford. It was known at one time as 'Bockhampton Path', since this was its ultimate destination. At Stinsford it passes this attractive building, formerly referred to as Gardener's Cottage and now called Three Bears Cottage.

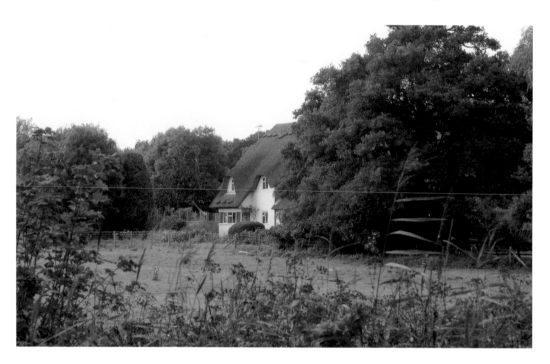

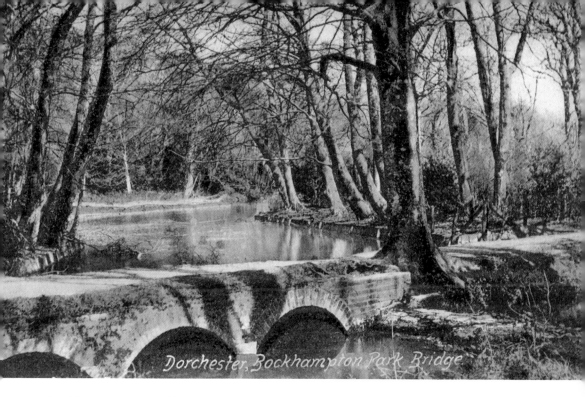

Dorchester, Bockhampton Park Bridge

Bockhampton Park Bridge, c. 1905
This was known at one time as Bockhampton Park Bridge. It lies just east of the cottage in the previous view, below the grounds of Kingston Maurward House and at the junction of 'Bockhampton Path' and a path running from St George's Road across the watermeadows and up to Stinsford village.

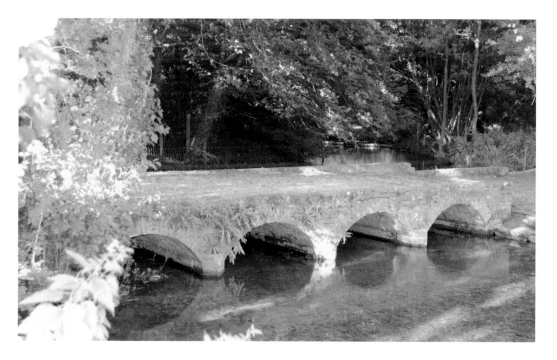

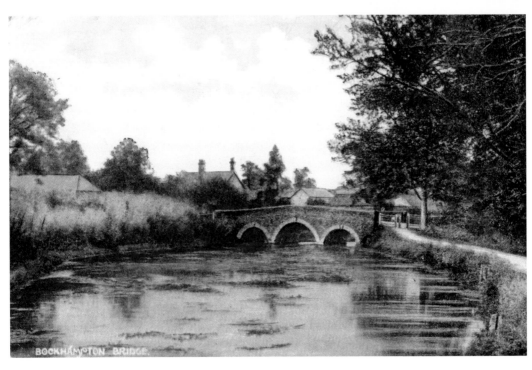

Bockhampton Bridge.

Bridge at Lower Bockhampton, c. 1900
'Bockhampton Path' continues along below Kingston Maurward's grounds to this eighteenth-century bridge at the bottom end of the village of Lower Bockhampton, one of the main settings for Thomas Hardy's 'Under the Greenwood Tree'.

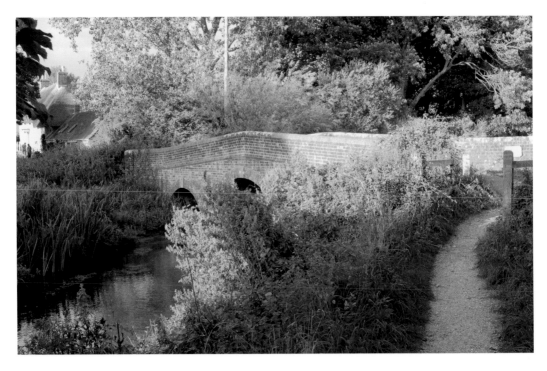

VILLAGES AROUND DORCHESTER

We finish off with a tour of some of the villages in the area, which I have arranged from west to east.

Abbotsbury

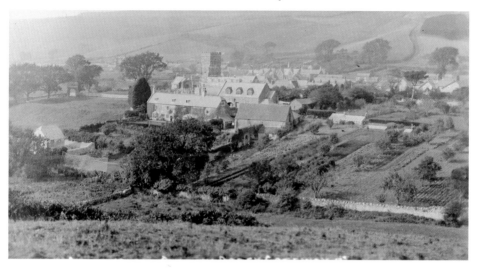

General View of Abbotsbury, c. 1920

Abbotsbury lies eight miles south-west of Dorchester and is a historic and picturesque place that, deservedly, draws many visitors. The village's name records its link with a medieval abbey, parts of which can still be seen. In the older photograph, the village is seen from the hill to the south-east. There are no public rights of way here, so my photograph was taken from the hillside below St Catherine's chapel to the south-west.

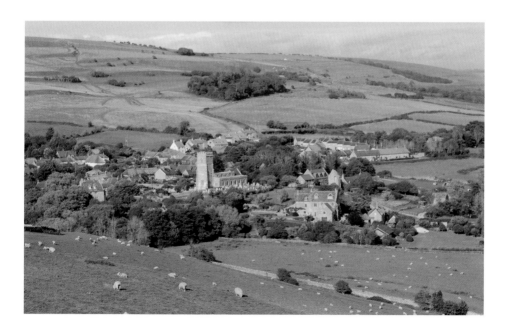

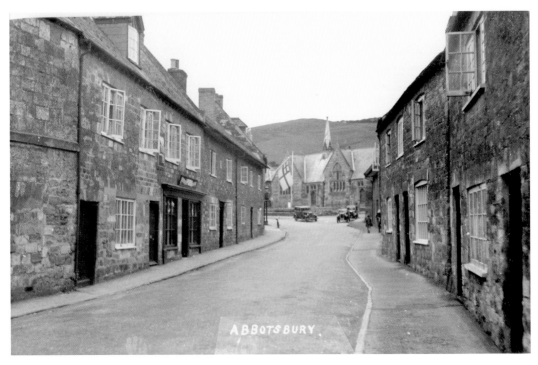

Looking up Market Street, c. 1930

What is now the village hall but which was originally the local school, built in 1848, can be seen at the end of Market Street. The flag in the older photograph is probably hanging outside the Ilchester Arms.

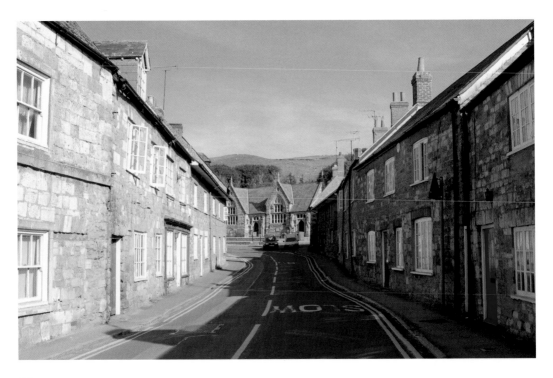

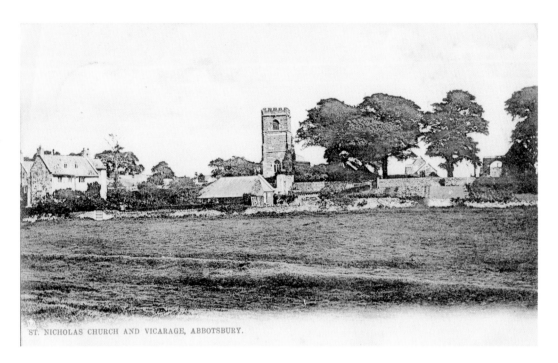

ST. NICHOLAS CHURCH AND VICARAGE, ABBOTSBURY.

Abbotsbury's Parish Church, *c. 1900*

Dedicated to St Nicholas, Abbotsbury's parish church dates from the late Middle Ages and originally would have been the church of the ordinary people of Abbotsbury, not the monks. However, a thirteenth-century stone carving of an abbot that must have been part of his tomb, has found its way into the porch.

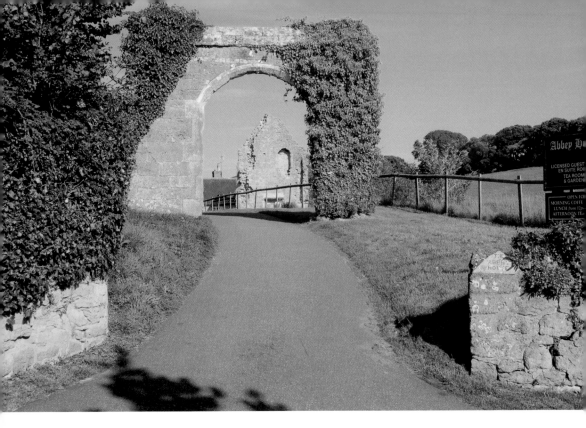

Abbey House, c. 1920

The gateway that led to the abbey today bestrides the drive to Abbey House. Through its arch the surviving gable end of one of the abbey buildings can be seen.

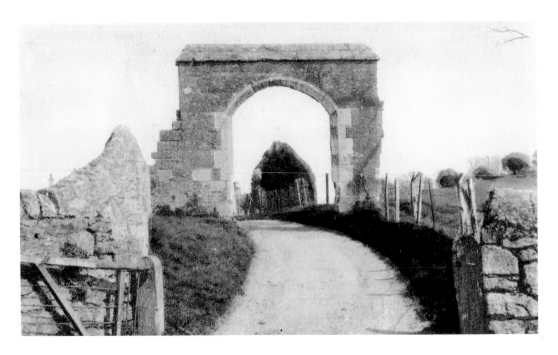

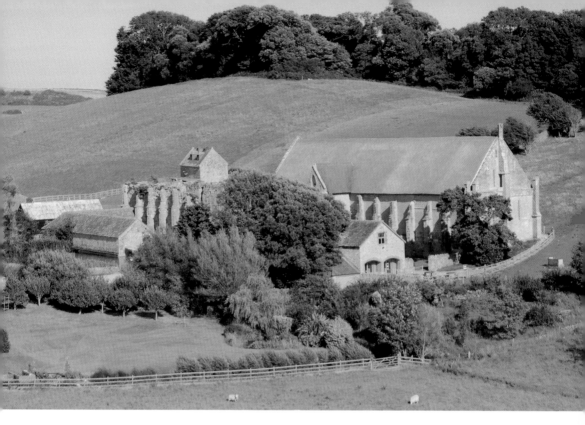

The Tithe Barn, *c.* 1900
The six-hundred-year-old Tithe Barn is the most completely surviving part of the abbey complex, because it retained its practical value as an agricultural store after the abbey had gone out of use. It is the largest such building in the country, being over 30 feet high and nearly 300 feet long, and has recently been restored as a tourist attraction.

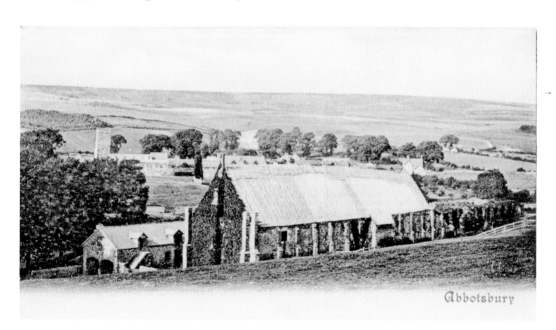

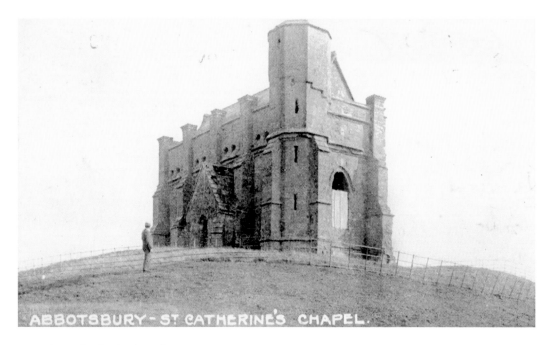

St Catherine's Chapel, *c.* 1910

On a hilltop above Abbotsbury, St Catherine's chapel was associated with the abbey and is about as old as the Tithe Barn. It also survived because it had a practical use — it is clearly visible from the sea and so helped ships sailing along the coast to determine their location.

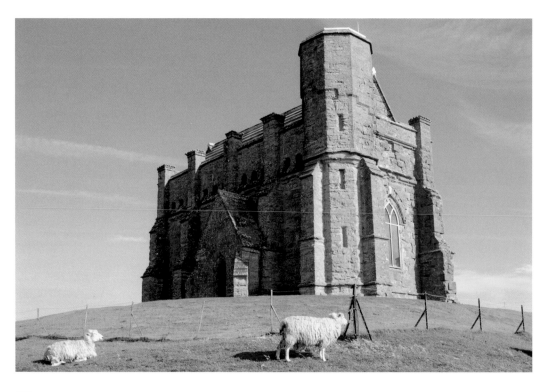

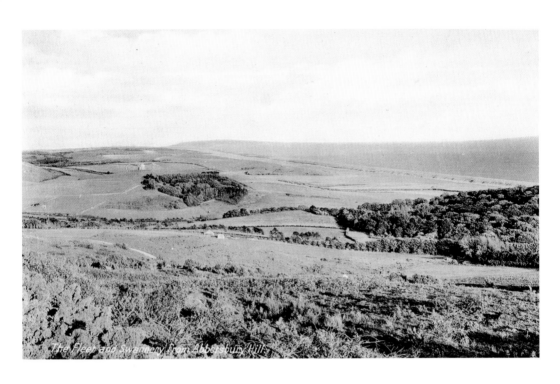

The Fleet and Swannery from Abbotsbury Hill

View from Abbotsbury Hill, *c.* **1910**
As the road to Bridport leaves Abbotsbury it climbs up Abbotsbury Hill and the view back to the Fleet, Chesil Beach and Portland is one of the best in Dorset. These photographs have St Catherine's chapel to left of centre.

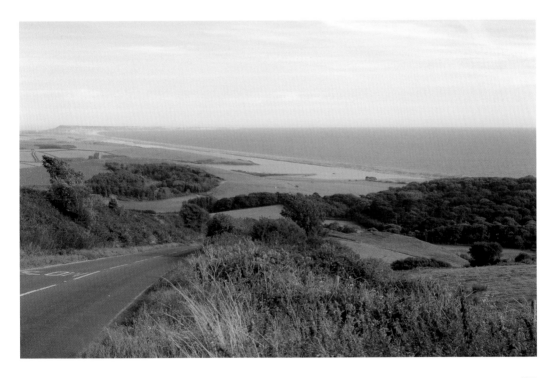

Frampton

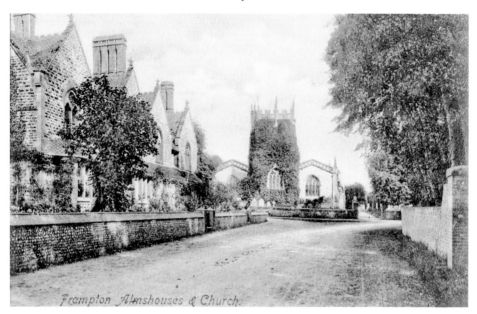

Frampton Almshouses & Church.

Village View, *c.* 1905

Frampton is about five miles up the Frome valley from Dorchester on the road to Maiden Newton. Then and now this is a classic Dorset view of a group of four estate cottages and the parish church. The cottages, which were built in 1868, have not only gained television aerials in the time between the two photographs, some of their chimneys have been demolished as well. Parts of the church date from the fifteenth century, and its tower was rebuilt in 1695. The wall on the right in the earlier view was removed about ten years ago.

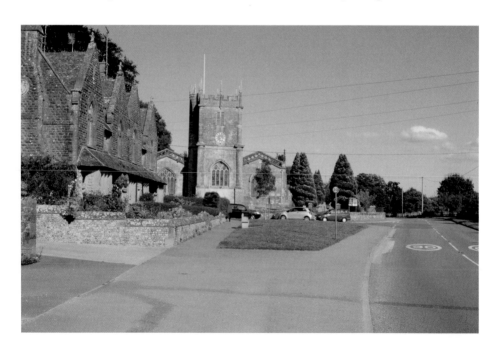

Charminster

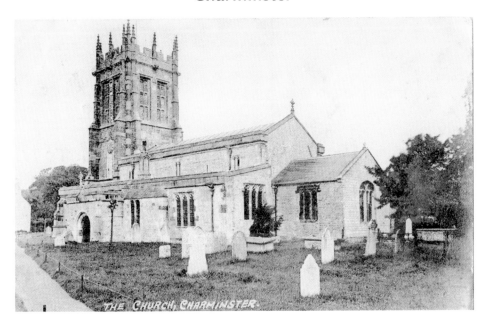

Charminster Parish Church, c. 1905

This is another classic view of a local parish church. Charminster is less than two miles from Dorchester, and were it not for the river Frome and its flood-prone valley, could have been a suburb of the town by now. The church is beside the river Cerne, with a bridge and a ford crossing the river close by. Parts of the building date back to the twelfth century, and inside there are monuments of the Trenchard family of nearby Wolfeton House.

Cerne Abbas

Cerne Abbas vies with Abbotsbury to be the best-known village around Dorchester. It is also receives many visitors, who are generally drawn initially by the Giant, but then come into the village for refreshment only to be pleasantly surprised by further attractions such as the site of the abbey, a riverside walk and lots of attractive buildings.

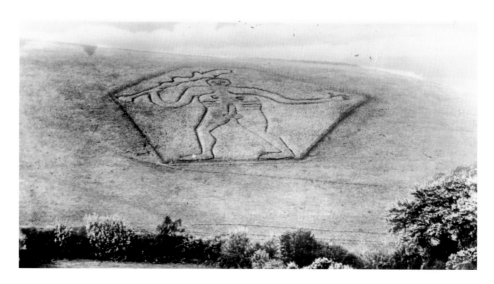

Cerne Abbas Giant, *c.* 1900
The origin of the Cerne Abbas Giant has been much debated. The club in particular is a symbol of the Classical god Hercules, so it has been suggested that it dates from Roman times. However, since it is not mentioned in any document before the later seventeenth century, the favoured view currently is that it dates from around the 1650s, when Oliver Cromwell was Lord Protector of the country. Cromwell's supporters called him the 'new Hercules', and the figure was probably a satirical reference to this. Note how the fenced-off area around the figure has been increased, which looks better aesthetically.

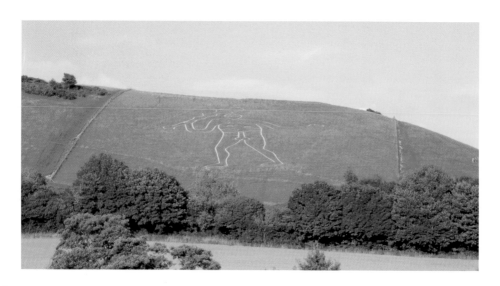

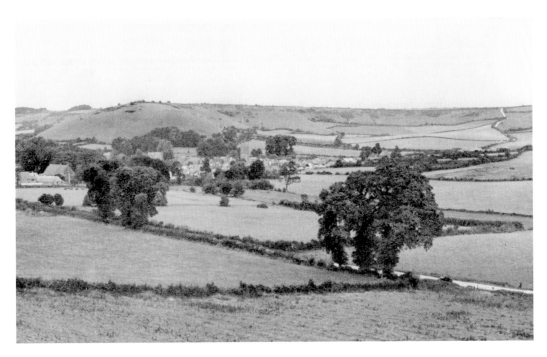

Cerne Abbas seen from the South-West, *c.* 1930

The older view is taken from above the road from Dorchester, which you can see in the foreground. This is now private land, and I have taken mine from the roadside. The large building on the left in the older view is the fourteenth-century Tithe Barn that originally belonged to Cerne Abbey.

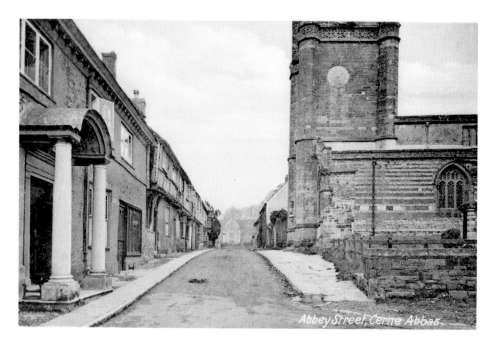

Abbey Street, *c.* 1910

Abbey Street is arguably the most historic part of the village. Abbey House can be seen at the far end of the street — it is the much-altered former gatehouse of Cerne Abbey. A guest house and the porch of the abbot's hall survive in the grounds behind, but the rest of the structure of the abbey has gone. Recycling is nothing new, and many of the houses in this view and elsewhere in the village must have been built using the abbey's stone. As at Abbotsbury, the church on the right was that of the townspeople, not the abbey.

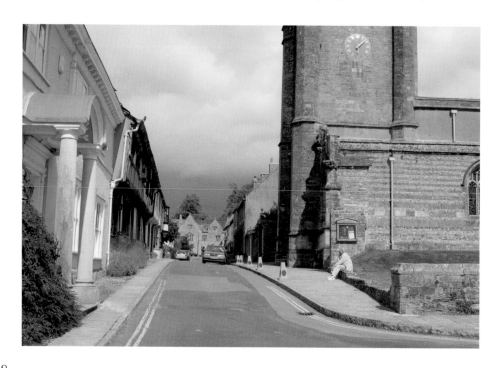

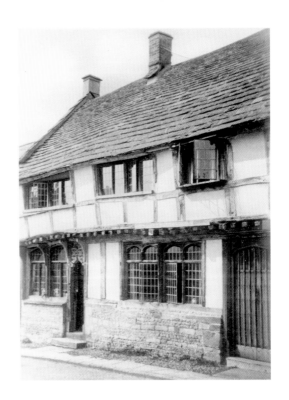

Pitch Market, *c.* 1930
The Pitch Market is one of the buildings on the left side of the previous view. From its construction and style it has been dated to the early sixteenth century, so may have been built when the abbey was still in use. Fortunately it has hardly changed between the two photographs being taken.

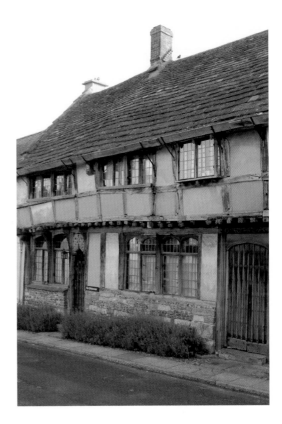

Puddletown

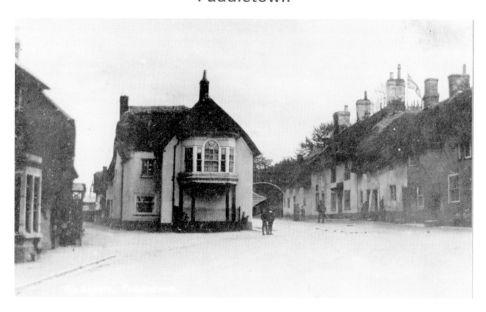

The Square, *c.* 1905

Lying five miles north-east of Dorchester, Puddletown is one of a string of villages in the valley of the river Piddle, from which it was named. So, it was originally 'Piddletown', but nineteenth-century sensibilities changed its name, and that of some other villages in the valley. This is The Square, the centre of the old village. It is a quiet spot because the main roads through the village have avoided it for over a century, and even these have been superseded by the bypass built in the 1990s. The central house in this view, with its projecting bay window supported on wooden columns, dates from the later eighteenth century.

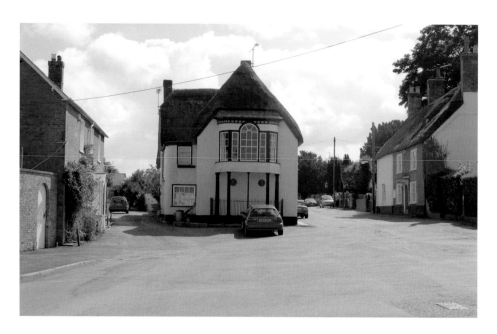

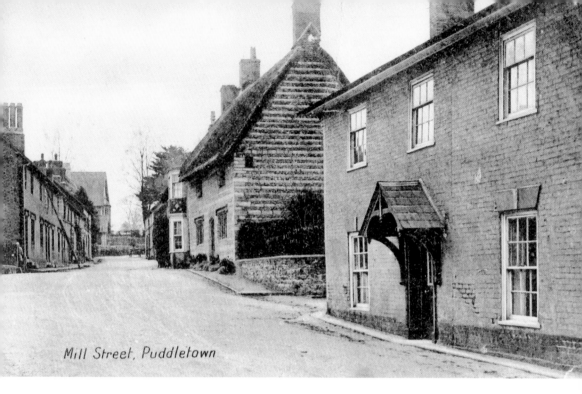

Mill Street, Puddletown

Mill Street, *c.* 1920

Mill Street runs from the main street to the river Piddle, passing along one side of The Square as it does so. The viewpoint here is close to The Square, looking in the direction of the main street.

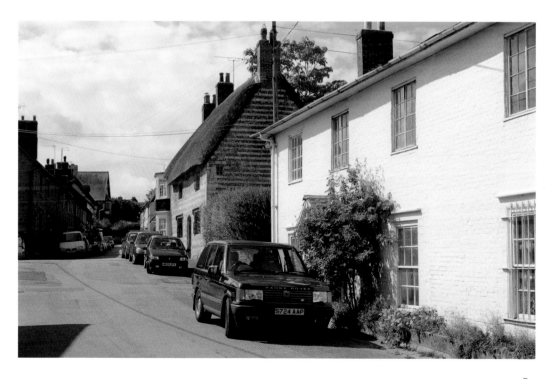

Tincleton

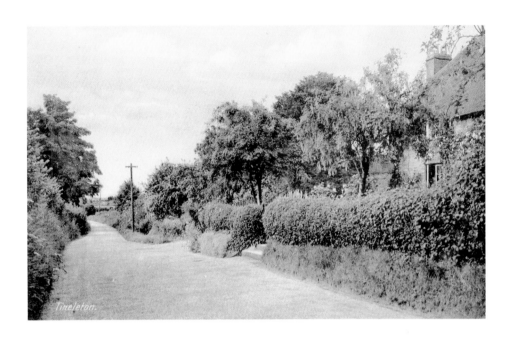

Village View, *c.* 1930

Tincleton is about five miles east of Dorchester down the Frome valley. I am not certain that the two photographs were taken from the same location, but at least they show what the village was and is like, a pleasant spot with widely-spaced houses.

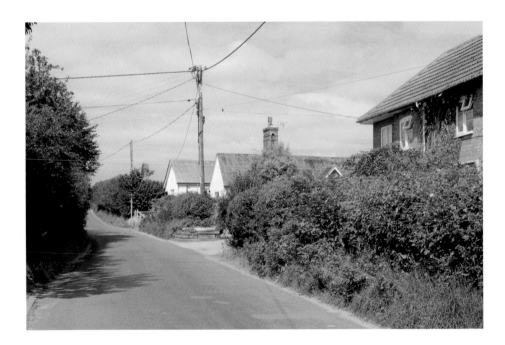

Tolpuddle

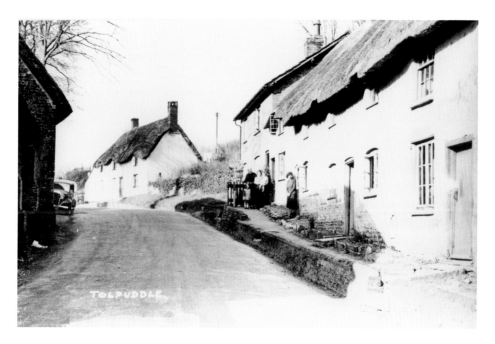

Main Street, c. 1930

This is the next village down the river Piddle after Puddletown. The view looks up the main street from the top of the village green. A gap between the houses in the older photograph has been filled by one that was built in traditional style a few years ago.

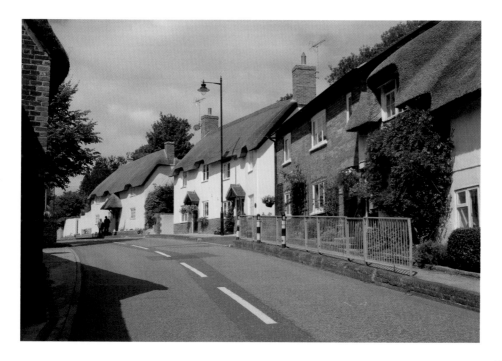

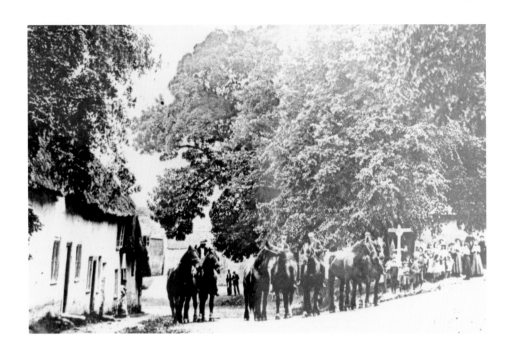

The Green, *c.* 1900

The village is famed for the Tolpuddle Martyrs, the six men sentenced to transportation in 1834 after forming a trade union. The green was one of their meeting points, and a commemorative shelter was erected here on the hundredth anniversary of their sentencing. The gathering shown in the older photograph could be a celebration of them.

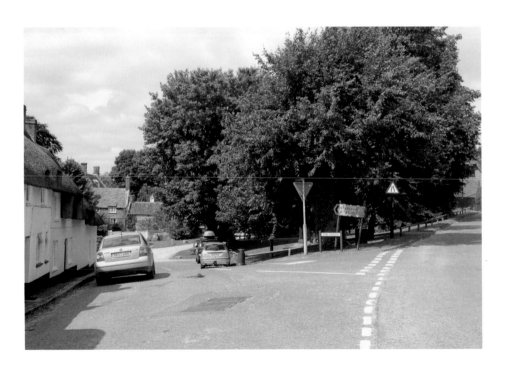

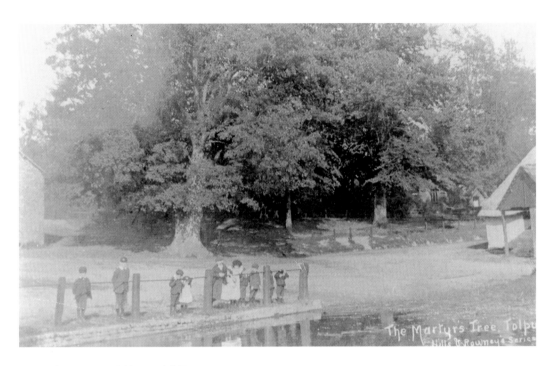

The Martyrs' Memorial Tree, c. 1910

The older view looks at the green from the south. The closest tree is the Martyrs'
Memorial Tree, under which the men held meetings. The area in the foreground has
changed somewhat and is private land, so the modern view looks at the tree from the
lane to Southover.

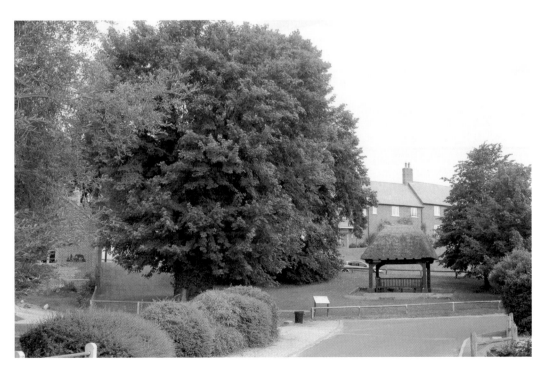

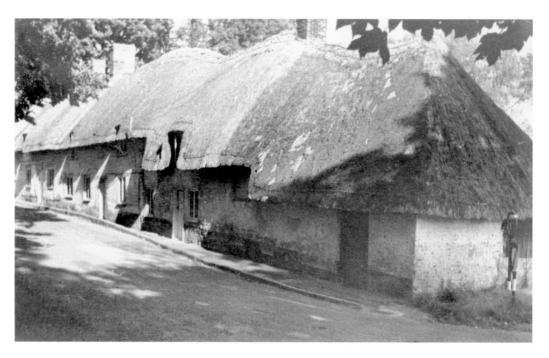

Cottages by the Green, c. 1900

Here is the distinctive row of cottages on the lower side of the green. Two of them date back to the seventeenth century, while the nearest one in this view has a particularly venerable age, having been built in the fifteenth or sixteenth century.

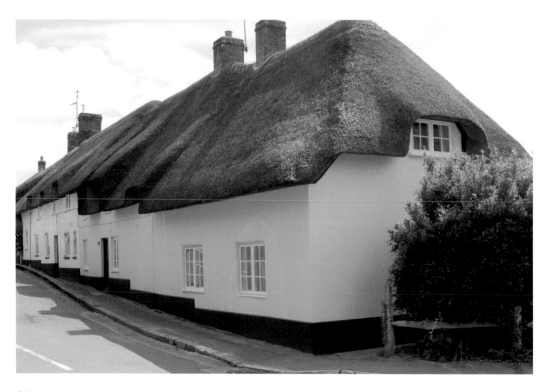

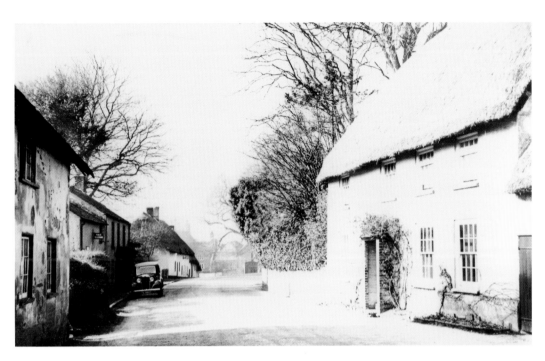

Main Street, c. 1930

This view is taken from a little way east of the green along the main street. The distinctive eighteenth-century South View House is on the right, and you can make out the area around the green in the background.

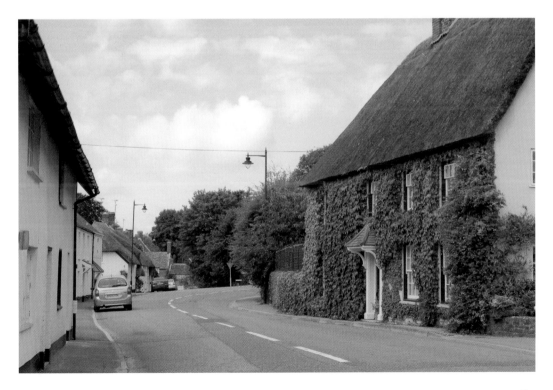

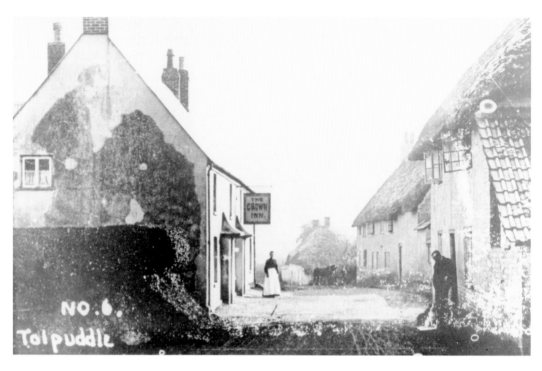

The Crown Inn and Main Street, *c.* 1900

Turning around and heading away from the green we get this view. The Crown Inn on the left burnt down in the mid-twentieth century and was replaced by a new pub, now called the Martyrs Inn. Tolpuddle and its Martyrs are still held in high regard by the Trades Union Congress, and this pub was formally opened by Vic Feather, General Secretary of the T.U.C., 21 September 1971.

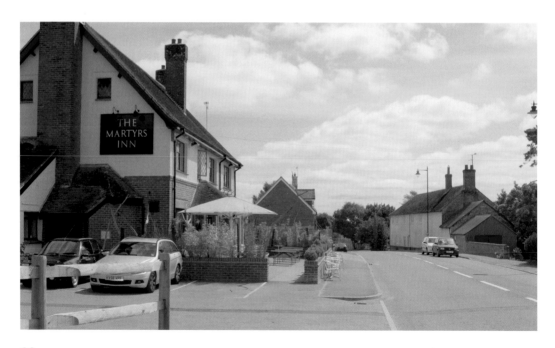

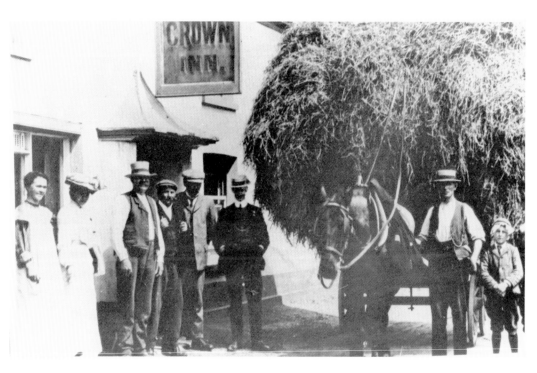

The Crown Inn, *c.* 1900
Since I was unable to find a group of people who possessed a hay-cart and were willing
to pose for a photograph outside a pub, I hope you do not mind a modern view that just
shows the Martyrs Inn.

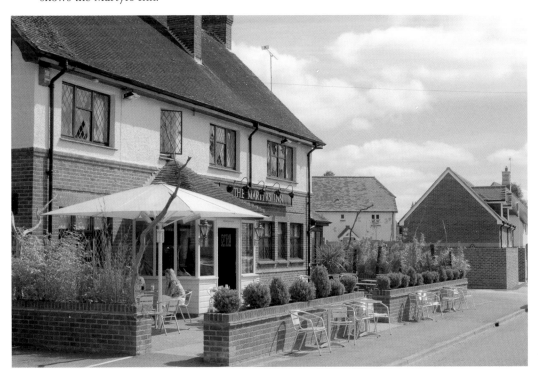

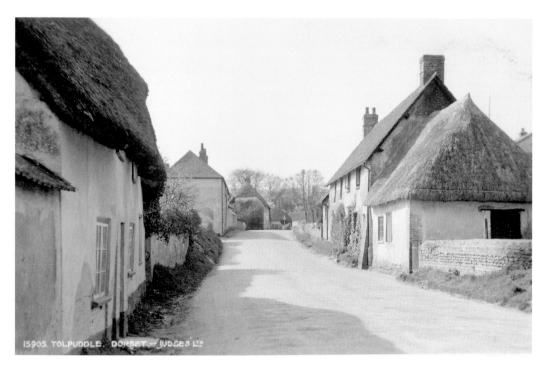

Main Street, c. 1930

Then and now Tolpuddle stretched for quite a way along the road east of the central green. Here are some of the cottages at the eastern end of the village — the one on the left in the older view has since been demolished.

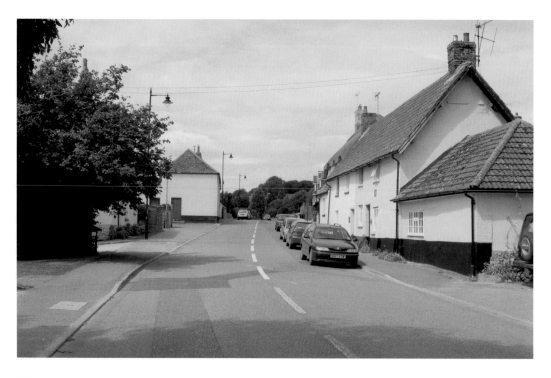

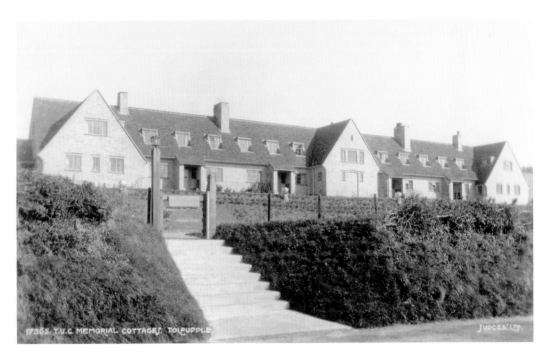

Memorial Cottages, *c.* 1935

These Memorial Cottages at the west end of the village were built by the Trades Union Congress in 1934, the same year as the shelter was erected. One now houses a display on the Martyrs and their legacy.

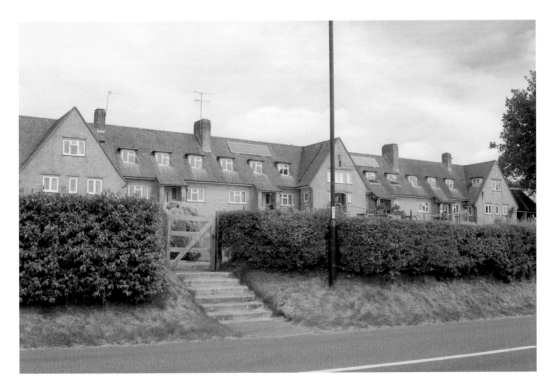

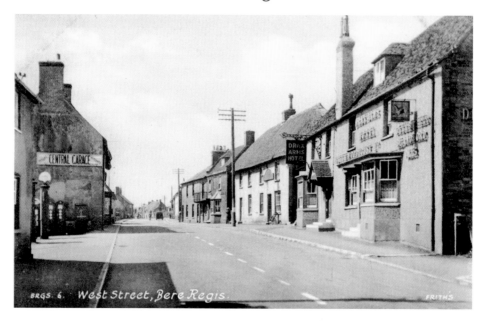

Main Street, c. 1935

We have now travelled some ten miles east of Dorchester, and finish at a village probably best known for being the place where the A35 divides, with one route heading towards Wimborne and eventually London, the other towards Poole and Bournemouth. Here is the main street. The Drax Arms on the right takes its name from that of the local estate. The garage on the left in the older photograph has been replaced by housing. Today, the village has a bypass, and the street is almost as quiet as when the older photograph was taken.

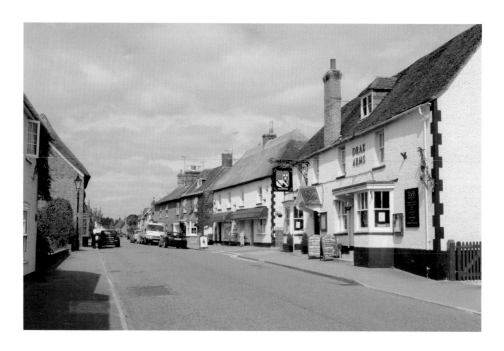

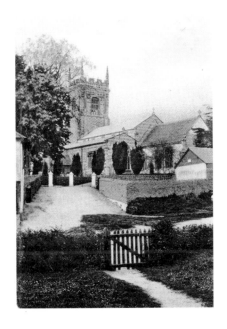

Bere Regis Church, c. 1905

In a just world the village would be best known for this church. Parts of it may be Saxon, but its best features include the tower with its chequered pattern of stone and flint, the late fifteenth-century wooden roof of the nave — generally agreed to be the county's best — and tombs of the local Turberville family, who became the D'Urbervilles to Thomas Hardy. Since a tree now obscures much of the church from the spot where the early photograph was taken, there is an extra modern view taken from inside the churchyard.

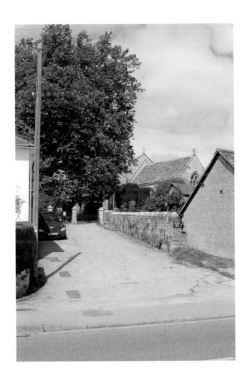

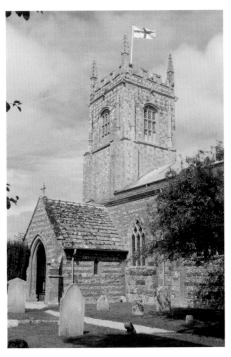

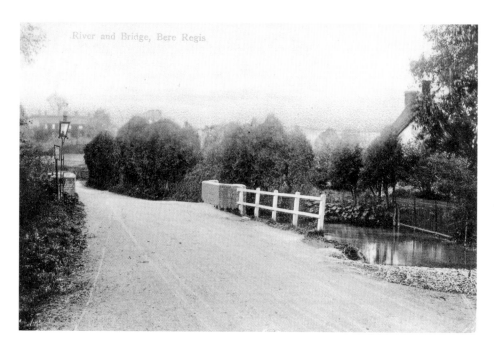

Bridge over the Bere Stream, c. 1905

This bridge takes the road to Wool over the Bere stream, a tributary of the Piddle, in the south-east part of the village. The superstructure shown in the early photograph, as well as the cottage on the other side, have been demolished and today it is less easy to recognise that there is a bridge here.

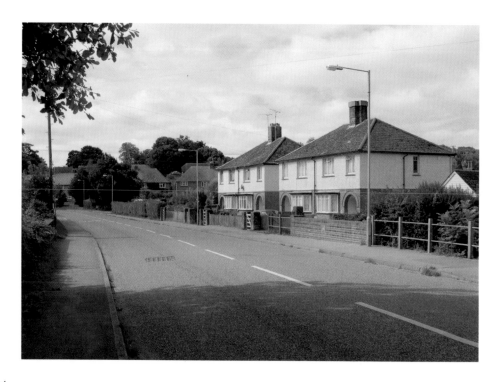

Abbotsbury, *c.* 1910.

Acknowledgements

For their help in producing this book I would like to thank Andy Helmore, Glyn Williams, Andy, Jeni and Eva Foster, Matt Hallett and Rachel Easter, as well as Dennis Holmes, Town Clerk of Dorchester Town Council, John Lowe of Dorset County Council and Malcolm Savage and the Duchy of Cornwall.

Mrs Rose Barnes kindly lent me the two 1960s photographs of Charles Street. All the other older images are from my own collection.

Also available from Amberley Publishing

Christchurch Through Time
by Sue Newman

Christchurch Through Time is a unique insight into the illustrious history of this part of the country. Reproduced in full colour, this is an exciting examination of Christchurch, the famous streets and the famous faces, and what they meant to the people of this town throughout the nineteenth and into the twentieth century.

Price: £12.99
ISBN: 978-1-84868-358-7

Available from all good book shops or from our website
www.amberleybooks.com